IMAGES OF ASIA

Traditional Festivals in Thailand

Titles in the series

Traditional Festivals in Thailand

RUTH GERSON

KUALA LUMPUR
OXFORD UNIVERSITY PRESS
OXFORD SINGAPORE NEW YORK
1996

Oxford University Press

Oxford New York
Athens Auckland Bangkok Bombay
Calcutta Cape Town Dar es Salaam Delhi
Florence Hong Kong Istanbul Karachi
Madras Madrid Melbourne Mexico City
Nairobi Paris Shah Alam Singapore
Taipei Tokyo Toronto

and associated companies in
Berlin Ibadan

Oxford is a trade mark of Oxford University Press

Published in the United States
by Oxford University Press, New York

© Oxford University Press 1996
First published 1996

British Library Cataloguing in Publication Data
Data available

Library of Congress Cataloging-in-Publication Data
Gerson, Ruth, 1943 –
Traditional festivals in Thailand/Ruth Gerson.
p. cm. — (Images of Asia)
Includes bibliographical references and index.
ISBN 967 65 3111 1:
1. Festivals—Thailand. I. Title. II. Series.
GT4878.A2G47 1996
394.2'6' 09593—dc20
95–50000
CIP

Typeset by Indah Photosetting Centre Sdn. Bhd., Malaysia
Printed by KHL Printing Co. (S) Pte. Ltd., Singapore
Published by the South-East Asian Publishing Unit,
a division of Penerbit Fajar Bakti Sdn. Bhd.,
under licence from Oxford University Press,
4 Jalan U1/15, Seksyen U1, 40000 Shah Alam,
Selangor Darul Ehsan, Malaysia

To the memory of my father
Hermann Moses
who loved Thailand so much

Preface

THIS book took shape slowly in my mind. I had lectured on the subject of traditional festivals in Thailand as part of the introductory lecture series of the National Museum Volunteers in Bangkok. In preparing the lecture, I scoured libraries, bookshops, and private book collections to gather the initial information presented herein. It did not take me long to realize that the research for this book was going to be more extensive than that for the lecture. Furthermore, I needed good pictures to illustrate these colourful events, and the best way to obtain them was to attend the festivals myself. This carried me over a substantial part of Thailand, embarking on unexpected adventures, visiting remote villages, and experiencing many festivals in their most authentic way. Being a fluent speaker of Thai, I persistently asked questions, inquired about unclear details, and requested explanations, all of which were provided happily by friendly strangers, only too eager to assist. Rolls of film yielded some rather interesting images, some of which are included in this text.

The festivals covered in this book are the major ones celebrated in Thailand. All occur once a year, with some having been celebrated for centuries, such as the Buddhist festivals, while others have only been observed for a few decades, like the commemorations of historical events. These events have changed over the years as the life-style of the Thais has gradually changed. Most of the festivals still reflect their origin, and are avidly observed in Thailand. There are, however, certain events which have faded from Thai culture, leaving only a hint of their colourful past, such as the Giant Swing Ceremony. Other festivals came to the attention of the Thai public only in recent years, being remote and regional in nature, such as the Ghost Festival. In all, the Thai calendar of festivals appears to present a good balance of annual events.

As the writing and completion of this book demanded on-site research, including original photography, and since each festival is celebrated only once a year, with some not open to the public, I

greatly depended on the help of others whom I wish to thank. They are: Office of His Majesty's Principal Private Secretary, with permission of His Majesty the King, for providing and permitting the use of royal pictures; Prince Subhadradis Diskul for personally translating certain Thai texts and for checking the contents of this book; the National Archives of Thailand for allowing the reproduction of old photographs and prints, especially Khun Juthatip Ansusing for her help at the archives; National Museum Bangkok, National Museum Volunteers, Tourist Authority of Thailand, and *Le Petit Journal* for permitting the use of their pictures in this book; Fumiko Boughey and Rita Ringis for their assistance in logistics; Sally Lavin, Sharon O'Toole, Eileen Deeley, Elizabeth Dhé, Monique Heitmann, John Everingham, and Walter Unger for contributing excellent photographs; Ann and Walter Unger for their assistance in selecting the pictures for this book, and my sons Colin and Shane who helped in narrowing the selection. I also wish to thank Acharn Smitthi Siribhadra of Silpakorn University for clarifying obscure details, and the Siam Society for allowing access to their rare books collection.

Bangkok
August 1995

RUTH GERSON

Contents

1
Introduction

CEREMONIES and festivals abound in Thailand contributing colour to its life. They serve as suitable occasions, particularly in rural areas, to rejoice and release pent-up energy accumulated throughout months of hard work, fatigue, and frustration. Indeed, the Thais have developed a great talent for celebrating and having *sanuk*, a descriptive expression for having a good time.

The majority of Thai festivals and holidays are based on the lunar calendar, adhered to for centuries, with December being the first month of the lunar year. As a result, a great number of festivals and religious holidays coincide with the full moon. Agriculture, evolving around the monsoon cycle, is another factor in forming the annual calendar. With time, new elements helped shape the Thai calendar: the solar method of calculation introduced from India, decisions made by court astrologers, dates selected by government officials, and in later years, holidays of Western origin. Certain festivals and holidays are fixed dates on the Thai calendar, while the rest are based on lunar or astrological calculations.

Most festivals were introduced in Thailand centuries ago, as one culture after another held sway in this lush and largely fertile land. The Indian influence pervades, having been introduced directly by merchants and Buddhist missionaries, and by other sources that came by way of Sri Lanka, Cambodia, and Burma. In time traditional festivals gradually shed some of their original features, acquiring a Thai 'flavour' as they became perpetuated through annual celebrations. This resulted in a fascinating blend of Buddhism and local animist beliefs. Also celebrated are legends and glorified historic events emulating grand ceremonies of the past. These traditional festivals have strong Buddhist overtones, as most Thais are Buddhists following the Theravada tradition. Most Buddhist festivals take place just before the rainy season, and immediately following it. These are celebrated all over Thailand and emphasize

the important role the monks hold in Thai society, preserving the spiritual welfare of the nation.

Fertility is another dominant theme in traditional north-eastern festivals, expressed in fervent wishes for bountiful harvests and life-giving rain. To summon the forces of nature, graphic devices are playfully used, leaving little to the imagination. These festivals take place at the end of the hot season between May and June, imploring the rains to come and water the fields. Fiery rockets, phallic-shaped tools, and all other possible means are employed to convey to the guardian spirits of nature the urgency of the anticipated monsoons.

The calendar of events appears to get more crowded each year. Although the practice of certain ancient festivals has been abandoned, not all have been forgotten; some are currently observed in updated versions. Furthermore, new festivals have emerged adding to the extensive list. Some are drawn from ancient customs and legends while others are productions of the Tourist Authority of Thailand. All successfully draw crowds to these flourishing events. Regional differences in celebrating festivals as well as the observance of indigenous festivities have made Thais tourists in their own land. Of the festivals, all, but royal ceremonies held within the palace, are open to the public.

In the crowded Thai calendar, every month has at least one festival. However, months such as May and October boast up to four events each. Every festival is important and is celebrated once a year, except for the Royal Barge Procession. This usually includes parades, beauty pageants, loud music, liquor, and food, and is celebrated with great abandon. Exceptions are the major Buddhist holidays and royal festivals commemorating significant events of the present Chakri dynasty.

To understand the Thais, their culture, customs, and behaviour, one must participate or at least attend a few traditional festivals, gaining a brief glimpse into their past, which in some cases has lingered into the present.

2
Buddhist Festivals

THAILAND is predominantly a Theravada Buddhist country with a population that devoutly follows the teachings of the Buddha. Although traces of animism linger, Buddhism has struck deep roots in Thai life and has become inseparable from its culture. All major religious festivals are therefore essentially Buddhist in nature, commemorating important events in the life of the Buddha. Unlike in most religions, the Buddha is not viewed as a god but merely as a teacher, and the essence of his teachings constitute the core of the Buddhist religion.

Although the Buddha's teachings were passed down orally in the centuries following his death, later sages realized that these words must be recorded to preserve the knowledge that they had inherited. They did so by recording from memory the many sermons that the Buddha had preached during his lifetime. Further writings and discussions added over the years evolved into the Buddhist theology. The masses gained knowledge about their faith by listening to monks read sermons and chant ancient prayers, while they learned visually from the animated mural paintings found on temple walls. Moreover, to enable worshippers to express their devotion, sites of great events in the Buddha's life were designated as places of pilgrimage, and the days on which these occurred became traditional days of observance. In Thailand, three major Buddhist celebrations recount these special events and are observed as public holidays.

The Thai calendar is based mainly on the lunar cycle, with religious and agricultural festivals being celebrated during the occurrence of the full moon, including the three main Buddhist events namely, Maka Bucha, Visaka Bucha, and Asalaha Bucha. The religious festivals provide a time when people all over the country flock to temples and pay their respects to the Buddha and his teachings. Although each of the three occasions commemorates a different event, the ceremonies and rituals that take place at the temple are very similar. These days are of great importance as they symbolize

3

what is known as *triratna* or the 'Triple Gem' concept in Buddhism. This concept encompasses the Buddha, his teaching known as the Dhamma, and the order of the monkhood, the Sangha, which he established. Maka Bucha, celebrated in February, extols the Dhamma, Visaka Bucha in May pays homage to the Buddha, and Asalaha Bucha in July honours the Sangha. As an expression of the *triratna*, many rituals in the temple are performed in threes. Devotees bow in obeisance three times before the image of the Buddha, they bring three items as offering—a flower, usually a lotus bud, a lighted candle, and a burning stick of incense—and with these they circle the *ubosot* (ordination hall of the temple) three times.

Each of the three items used as offering on Buddhist holidays symbolizes an ethereal concept. The lotus is the symbol of impermanence, pure and beautiful but subject to decay. The lotus also represents enlightenment, its growth compared to human struggle and achievement. Trapped in a watery mire, the lotus plant rarely grows high above others, but its distinctive blossom is equated to an enlightened person who spiritually rises above all men. The light of the candle symbolizes the light of wisdom, and the heady smell of the incense represents the sweetness of enlightenment.

The Main Festivals

Maka Bucha

Maka Bucha is observed on the full moon of the third lunar month, generally in late February or early March (December being the first month in the Thai calendar). As the second most important Buddhist event of the year, Maka Bucha commemorates the spontaneous gathering of 1,250 disciples of the Buddha who came to hear him preach (Colour Plate 1). It was said that each of these monks attained the saintly level of *arahant* by being personally ordained by the Buddha. In the evening of this gathering, the Buddha delivered his last major sermon, known as the 'Ovadha Patimokkha Patha', before passing into nirvana. In it he gave his disciples the 'Patimokkha', the rules all members of the Sangha must follow. He also foretold his coming death, three months hence.

4

Today, on Maka Bucha Day, a new version of this sermon is delivered at dusk, written by the pious Rama IV (King Mongkut).

This day is also known as the 'Four Miracles Assembly', recalling the unusual events of that day: the spontaneous gathering of the *arahant* (all previously ordained by the Buddha) at the Veluvana bamboo grove monastery, occurring at a time when the moon was full and the star Maka shone at its brightest. Hence the name of the holiday, Maka Bucha (with *bucha* or *puja* meaning devotional service in Sanskrit). Befitting the day, it now marks the founding of the Buddhist Association of Thailand.

Early in the evening, a devotional service is conducted in the temple, starting with a reading that declares the purpose of the occasion. A leader from the congregation, well versed in Pali, joins the monks and repeats the prayers aloud. The rest of the congregation sit inside the *ubosot*, hands clasped in an attitude of reverence, and listen to the chanting. When the prayers are over all worshippers join in the devotional circumambulation of the *ubosot*, walking around its exterior three times, clockwise, always keeping the temple on their right. Some people kneel before circumambulating, making silent wishes. Circumambulating clockwise indicates the cycle of life; walking in a counter-clockwise direction indicates the cycle of death, a ritual performed only at funerals.

At all religious festivals, lighting the first candle at the temple is a great honour, a privilege usually reserved for the chief abbot, a member of the royal family, or an important member of the community. This candle, known as the 'father candle', is fixed in a place of honour usually near a *bai sema* or stone tablet, one of eight surrounding an ordination hall to mark off the sacred area. This candle serves to light the candles of worshippers.

Hundreds of people flock to temples from dusk till the late evening hours, buying items for worship from any one of the vendors near by before doing their prayers. Some begin circumambulating the *ubosot* while the prayers of the monks can still be heard. Through the haze of smoke and faintly glowing candles, a continuous stream of people circle the building, paying their respects to the Buddha.

5

Visaka Bucha

The most important day on the Buddhist calendar is the Visaka Bucha. It commemorates the three major events in the Buddha's life: his birth, his attainment of enlightenment, and his death or passing into nirvana (Colour Plate 2). All three events are observed on the full moon of the sixth lunar month, Visaka, in late May or early June. An ancient Thai holiday dating back to the fourteenth-century rule of the Sukhothai kingdom, Visaka Bucha was revived by Rama II (King Isara Southorn) in 1817. He designated three days of observance as national holidays, one for each of those momentous events. These were eventually reduced to a one-day observance. Later in the nineteenth century, King Mongkut composed two prayers, in praise of the Buddha and his teachings, which are still intoned today during this occasion.

On Visaka Bucha people perform meritorious acts by bringing food in the morning to the monks in the temple. As on all other Buddhist holidays, the evening rites begin with a sermon, one composed for that day. Both monks and worshippers then circle the temple shrine three times clockwise, as is the custom, holding lotus buds, candles, and incense sticks in their hands and raised in a gesture of devotion. This ritual known in Thai as *wien tien*, or 'circling with the candle', gained its name from carrying a candle when circumambulating a sacred structure, and is considered an act of great merit. While circumambulation is usually done around the exterior of the ordination hall or the assembly hall of the temple, and on rare occasions on the inside, circling any religious edifice such as the *chedi* (reliquary) or even a large Buddha image also serves the purpose. Following the circumambulation people return to the prayer hall, some still holding lit candles in their hands, and listen to recitations of the Buddha's life and teachings. As the candle-light slowly fades and the hall plunges into darkness, five monks seated in a row chant the Visaka service—including the prayers composed by King Mongkut—thus concluding the service for this most significant holiday.

Asalaha Bucha

In late July or early August, as the full moon of the eighth lunar month passes through the constellation of Asalaha, two significant Buddhist festivals take place, one following the other. They are Asalaha Bucha, marking the anniversary of the Buddha's first sermon centuries ago, and Khao Pansa, the start of the three months of Buddhist Lent.

Asalaha Bucha is observed by monks and lay people alike, commemorating the Buddha's first sermon delivered to his five faithful disciples at the Deer Park in Sarnath near Benares. The Buddha, who had attained enlightenment two months earlier, spoke of life and its suffering, the causes of misery, and ways to overcome them. He said that suffering is inherent in life, caused by greed and desire, and can be overcome by means of the 'Eight Fold Path'. This part of the sermon became known as the 'Four Noble Truths'. The 'Eight Fold Path' constitutes instructions in behaviour, a seemingly simple yet complex code, concerning interaction with others, and understanding the inner self. By understanding these concepts one may gain wisdom and insight that will lead to the cessation of all suffering. This sermon became the core of the Buddha's teachings. In it he emphasized the impermanence of everything in a temporal world. Wealth and material possessions indicate attachment and desire which have no place in the Buddhist way of life. This is evident in the modest way Buddhist monks live.

Today on Asalaha Bucha people recall the fundamental teaching of the Buddha. They listen as monks chant prayers and repeat the words of that first sermon. As in the other religious festivals, they carry lotus buds, lit candles, and incense sticks as they do the triple circumambulation at dusk in a serene candlelight procession honouring the Buddha, his teachings, and the order of the monkhood (Colour Plate 3).

Related Festivals

Related festivals and ceremonies are observed together with the three major Buddhist holidays, recalling past traditions and related rituals. Most of these festivals include practices intended to acquire

merit, such as presenting the monks with gifts of food, candles, and other practical items that they will need during the long rainy retreat, a time when they must remain in the temple. The primary seasonal period for gaining merit follows the rainy season. At this time, robes are offered to the monks as they are free to travel once again. These offerings are presented in picturesque processions, displaying regional styles and customs.

Khao Pansa

The day of Khao Pansa follows Asalaha Bucha, marking the beginning of Pansa, the period of Buddhist Lent. In Thai the name means 'to enter the rainy season', and indeed Pansa coincides with the rainy season which lasts three months, from July to October. It is a time when all monks are confined to their monasteries and refrain from travelling or leaving the temple for any length of time.

Like most Buddhist traditions, this practice dates from the early days of Buddhism when monks customarily walked in the countryside and preached. With few roads to go through, monks had to traverse newly planted paddy-fields in the monsoon rains, inadvertently trampling the tender shoots. As a result, their robes became filthy, soaked by rain and soiled by mud. Since all monks were allowed to own only one set of robes each, as was the custom in Thailand years ago, the Buddha, according to popular account, asked the monks to stay in their monasteries for the duration of the rainy season to protect the rice shoots. In fact, staying in one place was a pre-Buddhist habit of the wandering ascetics of India who were unable to travel through swamps and swollen rivers at that time of the year.

The monks use this period of retreat to study and to teach newly ordained monks who according to tradition enter the monkhood shortly before the rainy season. This is a significant period for all Buddhists as it also commemorates the legend of the Buddha's ascent to Tavatimsa Heaven, one of several Buddhist heavens, to preach to his mother who had died when he was only seven days old. It is said that the Buddha remained there during the three months of rain, a period which in time became known as Pansa.

In preparation for this season, public ceremonies for acquiring merit take place. Individuals and groups present the monks with items they will need during the period of retreat. These include bathing robes which can only be used once Pansa has begun. Other items offered are candles and food. Lighting a Pansa candle is regarded as a special meritorious act as the candle is supposed to remain lit and illuminate the temple for the three-month duration. It is customary to bring a large candle as an offering to the temple, an occasion of great festivity. As on other Buddhist holidays, flowers, candles, and incense are offered by worshippers at the temple.

In the Grand Palace a special royal service is held, wherein the king, or a person appointed by him, changes the golden robes of the Emerald Buddha, the most revered image in the kingdom. The Emerald Buddha traditionally has three robe changes annually to coincide with the onset of the hot, wet, and cool seasons.

Throughout Pansa people continue to bring gifts to the monks—who in principle are confined to the monasteries—consisting mainly of items such as honey, sugar, fruits, and medicine. These gifts are presented with an appropriate prayer. The weeks of Pansa mark a period of prayer and contemplation for monks and laity, and a time when people make resolutions to become better persons. The period ends on the full moon in October, at the end of the rainy season.

The Candle Procession

During the few days prior to the onset of Pansa, candle presentation ceremonies take place in temples, an ancient tradition which featured elaborate processions in the eighteenth century organized by Rama I (King Chulalok). The basis for presenting candles to monks lies in one of the Buddha's sermons. In it he praised Anuruddha, an elder disciple, as a wise and enlightened man, one who had led people out of darkness. Thus, giving light as a gift became a meaningful gesture among the followers of the Buddha. The duality of such a light is evident, as it is both a physical and spiritual light.

Several weeks before the start of Pansa people devote their time

to making special candles to be offered on the day of Khao Pansa. These candles are made of beeswax. Several methods are used in making the candles, producing a variety of sizes and shapes. Easiest to make are the small candles, though these lack the dramatic effect that large ones give when displayed on their own. To enhance their appearance, several small candles are tied together to create a large candle, known as a bundled candle, using a technique rarely seen today. In this technique a piece of wood or banana stalk was used as a core to which candles were tied, with large ones at the bottom and small candles at the top arranged like a flower. Other methods of making large candles produce the ornamented candle and the sculptured candle. The first entails the pouring of melted wax into shallow, ornamental moulds. The mouldings are then applied to the surface of plain candles. The second involves the carving of the design directly on to the candle with a knife. This method is the most difficult and demands the greatest skill. The ornamented and sculpted techniques are the two most often used in preparing candles today.

When the candles are ready they are blessed by sprinkling lustral water on them. The candles are then given to temples to ensure the prosperity of the donors. Meanwhile, groups participating in the candle procession vie for the coveted prizes given to the most beautiful, most creative, or most original theme in the competition that ensues. The popular region for festive candle processions is the north-eastern part of Thailand, with most elaborate parades displayed in the city of Ubon Ratchathani (Colour Plate 4). There, food, drinks, songs, dances, and plays are features of the celebration. Most spectacular, however, is the procession of floats on which the candles are carried, bringing into view elaborate Buddhist, Hindu, and mythological wax figures (Colour Plate 5). These are arranged singly or in groups, and are accompanied by beautifully attired young women who represent heavenly beings.

Presented candles are installed in a temple where they are lighted and are expected to remain lit for the three-month period. In the event that a candle does not last that long, its flame is transferred to a lamp in the temple from which other candles are lit. Some

candles are true works of art and are kept on permanent display in the temple.

Ohk Pansa

A special day marks the end of the three-month rainy season. Falling on the full moon of the eleventh lunar month, usually in October, the occasion is known as Ohk Pansa and literally means 'leaving the period of rain'. It also signifies that monks are no longer confined to the temple and may travel once again around the countryside. The monks prepare for the day by tidying their robes and shaving their eyebrows and heads, acts customarily carried out twice a month, once at the time of the new moon and again during the full moon.

On Ohk Pansa people gather at the temple for morning prayers. Throughout the day they honour the *chedi* and other sacred structures at the temple, and after dark place lit candles around the entire temple compound and in front of their homes. The many flickering lights announce the end of the rainy season retreat, and the beginning of the season for merit-gaining ceremonies.

Ceremonies for Acquiring Merit

As monks emerge from their temples following the rainy season retreat, and travel in the countryside once again, devotees offer them food and gifts as a gesture of thanks for perpetuating the Buddhist religion during the Pansa period (Colour Plate 6). Every year from about mid-October to mid-November, Thai people engage in merit-gaining ceremonies. These merit ceremonies can be observed all over Thailand, and although similar in nature, there are certain regional variances.

Thot Kathin

Acquiring merit by bringing gifts to monks in the temple is an old Buddhist tradition practised throughout the year. Most significant, however, is the season for gaining merit following Pansa, a period spanning thirty days from the full moon of the eleventh lunar

month in October, to the full moon in the twelfth lunar month in November. It is called Thot Kathin, which translates as 'laying down robes'; *thot* meaning to place or lay down, and *kathin*, referring to the monk's robes. Of the various gifts given to the monks, the robes are the greatest in importance, lending the festival its name.

Buddhism teaches renunciation of earthly pleasures, and emphasizes awareness of one's inner self. To mark their humble existence, ancient ascetics draped themselves in old, discarded sheets, said to have been used as shrouds, to display utmost humility. These pieces of cloth were patched together to form robes and dyed in natural shades akin to brown. Today's robes are still pieced together according to traditional practice, a task which must be completed in a single day only. This is to show that no special effort was made to enhance these robes, indicating merely their functional use. The saffron colour of the robes, believed to disinfect the old cloths, is derived from plants and tree barks, producing the variety of shades found in nature, from pale yellow to dark brown. In addition to natural dyes, the use of chemical dyes has become common practice.

This annual presentation of robes dates back to the days of the Buddha. It was told that thirty pious monks travelled at the end of the rains from Patha to Savatthi (in India) to visit the Buddha. As the roads were still wet and muddy they arrived looking rather bedraggled. When the Buddha saw the monks' worn and soiled robes he allowed them to receive new robes once a year, at the end of the rainy season. This ancient practice continued through the ages, evident in an inscription from the Sukhothai kingdom dating from 1293 and attributed to its great king, Ramkhamhaeng. It reads: 'The inhabitants of Sukhodaya are given to alms, to the observance of the precepts and to charity.... At the end of the rainy season there takes place the *Kathina* ceremonies which last a month' (Wales, 1931: 209).

Kathin ceremonies of the past favoured water processions, known as Kathin Nam. In ancient Ayutthaya, devotees travelled by boat through its maze of canals as no roads existed in those days. When roadways opened after 1630 some merit ceremonies took the land route; this then became known as Kathin Pak or Kathin Bok. In Thailand both means of procession are still used, although

land processions are becoming more common as canals are being filled in.

Ceremonies for acquiring merit are conducted by individuals and by groups, rich and poor alike, bringing boon to the donors while benefiting the temples. These acts are gestures of gratitude to the monks for maintaining and propagating the teachings of the Buddha during the rainy retreat. A usual ceremony begins with prayers in the temple on the eve of the festival. The following day, in the early morning hours, the Kathin procession heads to a selected temple, led by music and lively drumming. The robes, each composed of three pieces—a shoulder shawl, a loin cloth, and an outer robe—are brought to the

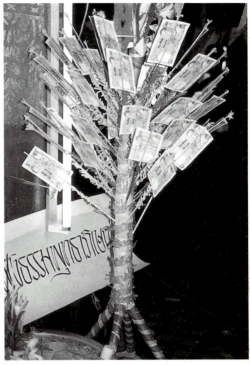

1. A 'money tree' made of 20-baht notes offered to a temple. (Ruth Gerson)

temple and carried around the main sanctuary three times. These, and items of food, toiletries, and simple utensils, are presented on elaborate trays to the monks after their daily meal, shortly past noon. Sometimes money is offered for the upkeep of the temple, the notes arranged as leaves on silver- and gold-coloured money trees (Plate 1). When Kathin ceremonies are completed in a temple, two *makara* (crocodile) flags are placed at the entrance to indicate that it has received the annual Kathin donations, and that worshippers find another temple for acquiring their seasonal merit.

The Devo Merit Ceremony

Another way of gaining merit during the season is through the Devo Ceremony, most often observed in northern Thailand. This occasion commemorates the descent of the Buddha from Tavatimsa Heaven (Colour Plate 7). To re-enact this event, a procession descends from a mountain or a high hill to create the effect of coming down from heaven.

Like many legends that are associated with the Buddha, this event inspires deep piety among Buddhist devotees. It was told that the Buddha's mother died when he was only seven days old, and that as an act of filial duty the Buddha spent one rainy retreat to teach her his doctrines. The Buddha ascended to Tavatimsa Heaven to meet his mother, while she in turn descended from the higher Tusita Heaven, where she dwelt, to listen to her son's teachings. These two heavens belong to the six lower heavens in Buddhist cosmology, each symbolizing a spiritual state attained by a person's acts in previous lives.

The full name of the ceremony is Devo Rohana, 'the descent from Deva or heavenly world', *deva* meaning angels in Sanskrit. In temples this story is read from the *Devorohana Sutta* in the evening, often from three pulpits, emulating the Buddha preaching to his mother in heaven.

This annual offering ceremony is customarily held on the last day of Pansa but can be performed on any one of the three days following it. To evoke the idea of descent, Buddhist monks gather at a temple on a hill and come down in a single row, holding alms bowls in their hands. Leading the procession is a Buddha image carried in a standing position, also holding an alms bowl. It is supported by two men clad in white, representing the Hindu gods Indra and Brahma, who accompanied the Buddha down from Tavatimsa Heaven (Colour Plate 8). In anticipation, people wait along the route the monks take, and seek merit by placing food in their bowls as they pass. The Devo Ceremony can also be conducted from temples built on level ground. In this case the monks file out of the temple in a row, and the customary ceremony proceeds. The dramatic Devo ritual ends when the last monk receives food

14

and completes the procession route, merging into a blur of saffron robes.

The Chak Phra Ceremony

The Chak Phra, or pulling the Buddha image, is typical in southern Thailand. This ceremony is performed both on land and on water and, like the Devo procession, it takes place on the first day of the season. It was told that as the Buddha reached the eastern gate of the city of Sankassa (in India), a large crowd was awaiting him, bearing offerings. Eager to acquire merit but unable to present these gifts personally in the crushing throng, devotees passed their offerings through others. This wondrous event is re-enacted annually wherein a standing Buddha image, holding an alms bowl, is placed in a pavilion-like structure topped by a ceremonial umbrella and mounted on a float. This large *naga* (water serpent)-shaped float is pulled in a manner recalling the progress of a water-borne craft. Traditionally, the float is followed by a single file of monks, with excited worshippers surrounding the Buddha image eager to participate in the ceremony. They attach ropes to the cart as a symbolic act of merit and pull it gently in unison, leading it from the temple through the countryside and the city streets. The land Chak Phra may be seen occasionally in other regions of Thailand, but the water Chak Phra is characteristic of the south.

Most impressive and dramatic is the Chak Phra Ceremony in the southern town of Surat Thani. There, both land and water processions take place. The water ceremony, however, is more popular, indicating the great enthusiasm that Thai people have for aquatic events. The Tapi River becomes the centre of activity as the principal Buddha image of Surat Thani is carried with great pomp on a barge (Colour Plate 9). The *naga* on both sides of the barge lend a supernatural quality as they glide on the water, recalling legends of ancient times. Several small boats tow the barge to a pre-designated place where the Buddha image is washed and draped with a new robe. The procession then moves on to a site where festivities and merry-making commence, with an abundance of food, loud music, and lively dance, usually lasting well into the night. The following

morning the Buddha image, aboard the barge, is returned to the temple.

The Royal Barge Procession

The king, as keeper of the Buddhist faith, is customarily the first to present the robes to the monks (Plate 2). He presides over the Kathin Ceremony at a temple of royal rank, travelling there by land or by water. A water procession has been favoured over the years as the water-level is high at the end of the rainy season and most young men are free to act as oarsmen since their fields are still submerged in rain-water. The Royal Barge Procession is held when the king travels from the Grand Palace, once the home of all royalty, to Wat Arun (Temple of the Dawn), to present a robe to the abbot.

This legendary procession dates back to the thirteenth century, in the early days of the Sukhothai kingdom when barges carried

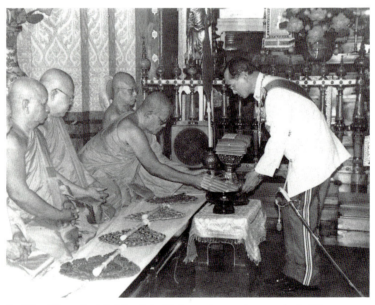

2. King Bhumibol Adulyadej offering robes to the monks in Wat Thepsirin, Bangkok. (Thai National Archives)

metaphoric names such as 'Appreciation of the Moonlight', and 'Victory on the Celestial River'. It was not until the seventeenth century, during the Ayutthaya period, that detailed accounts of the Royal Barge Procession were officially recorded. These tell of new barges being added to existing ones, designated for the royal Kathin Ceremony. Thus the Ayutthaya fleet became the largest and most magnificently known, its royal barges filling the rivers and canals of Ayutthaya. The many Europeans who resided in Ayutthaya kept historical diaries which included descriptions of the various barges, while the French created wonderful etchings of these (Plate 3). Thai artists immortalized them on traditional *khoi* paper manuscripts presently kept at the Thai National Archives (Plate 4).

The Royal Barge Procession is a majestic event, of grand vessels and colourfully attired men, recalling bygone days of glory. It extends over one kilometre in length, involving fifty-one barges and close to 2,000 crew members, mostly oarsmen. The procession moves in three parallel rows, the outer barges positioned for the protection of the principal barges in the inner row, with two smaller rows of escort barges between the principal barges and the outer rows. This formation evolved from traditional military processions on rivers as a kingdom's demonstration of power. Many of the barges are still equipped with canons, a vestige of the crafts' original use.

Many barges are classified and named after the purpose they serve, such as warding off evil, carrying drums, transporting soldiers, and bringing up the rear escorts. Other barges are named after mythical beings, displaying these figures on ornately carved masts. These include the royal bird Garuda, the white monkey Hanuman, and various demon heads. The barges were built during different periods, but those seen today are mainly of the Chakri dynasty.

The grandest in the royal fleet are the three principal barges which occupy the centre of the procession. The most distinguished, in order of importance, is the *Suphanahongs*, the golden swan, modelled after the vehicle of the Hindu god Brahma (Colour Plate 10). Renovated over the years, the barge was carved from a teak trunk measuring about 46 metres long. It was said that

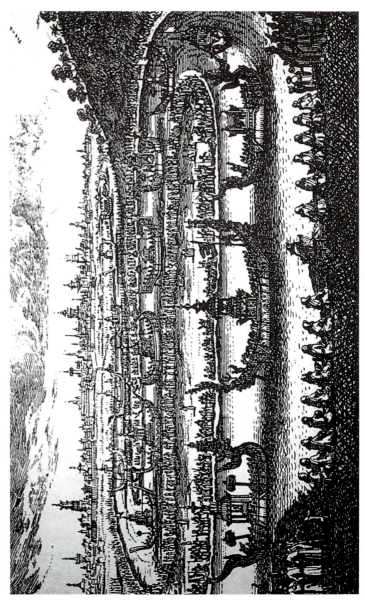

3. Seventeenth-century French engraving of the Royal Barge Procession in Ayutthaya. (Guy Tachard, *Voyage de Siam des Peres Jesuites, Envoyez par le Roy aux Indes & à la Chine*, A Paris, Seneuze et Horthemels, 1686)

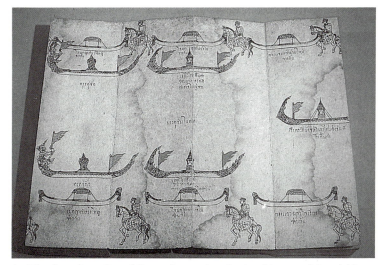

4. The Ayutthaya Royal Barge Procession depicted in a traditional *khoi* paper manuscript. (Thai National Archives)

the master craftsman who fashioned it threw away his tools when he finished and vowed never to work again. This anecdote is told to emphasize the importance of the barge. It has a crew of over sixty men, including oarsmen, helmsmen, standard bearers, officers, and a chanter. The swan barge is gilded and mirrored, with stylized wings flowing backward. It depicts the swan in flight, an image enhanced by the oarsmen's flashing silver and gold paddles. This barge carries the king during the Royal Barge Procession. The crystal tassel, ending in tufted yak's hair, is suspended from the golden swan's beak and indicates the king's presence on the boat (Colour Plate 11).

Second in rank is the *Anantanagaraj*, the *naga*-headed regal barge, which carries the king's gift of robes to the monks during the royal Kathin Ceremony. The seven-headed snake barge, each head crowned with a flame, glides smoothly on the river, expertly manoeuvred by fifty oarsmen. In the centre of the barge is a portable shrine housing a Buddha image, placed there for the Kathin Ceremony.

The third principal barge, and the oldest in the present fleet, is the *Anekajatphuchong*, built on the command of Rama V (King Chulalongkorn). It carries princes and other royalty and is manned by over sixty oarsmen. Bearing no figurehead, its prow curves in majestic elegance. From afar the surface of the barge appears rather plain, but a closer view reveals small snake-like figures and finely detailed carvings.

The dramatic effects of these magnificent barges are enhanced by the distant sounds of cadenced chanting, wailing horns, and muffled drums, sounds that drift ahead of the procession and mesmerize anticipating spectators. It is a magical experience to witness these and to listen to the lyrics of the 'Pleng Heh Reua', the boat song:

The King journeys by water
On the glorious Royal Barge
That sparkles like jewels
Gleaming paddles dip and rise. . . .

(Intravutr, 1982: 10–11)

The Royal Barge Procession has been a colourful event in Thai culture for several centuries, but this has been restricted in recent years due to the high cost of maintaining the fleet, the great number of people required in the procession, and the length of time needed for the preparations. In this current reign of King Bhumibol Adulyadej, the procession has taken place only four times to date. Of these, three were held as part of special events: the commemoration of the 2500th year of the Buddhist era in May 1957; the bicentennial celebration of the founding of Bangkok and the present Chakri dynasty in April 1982; and the celebration of the King's sixtieth birthday, in a Kathin Ceremony held in October 1987.

3
Agricultural Festivals

IN a country that has been primarily agricultural for centuries, the forces of nature are of utmost importance. Although sunshine and rain are abundant in Thailand, divine forces are still consulted annually to ensure a good crop, particularly of rice, the staple food. To be assured of plentiful rain, especially in the parched north-eastern region of Thailand, curious methods are applied, rooted in animism, myth, and ancient practices, to mollify the myriad spirits and elicit their help in creating favourable conditions for the forthcoming harvest. These ceremonies are held at the height of summer during the months of May and June.

The Ploughing Ceremony

Raek Na, or the Ploughing Ceremony, literally means 'the first ploughing'. It marks the start of the rice-planting season when farmers from all over the country converge in Bangkok to witness the rites. Falling on the sixth lunar month (May), the exact date for this event varies annually, determined by court astrologers who select an auspicious day for the ceremony. Ploughing ceremonies have ancient origins in China and India with the Thai following the Indian tradition. Two well-known legends mention these ancient rites. In the *Ramayana*, the classic Indian epic, one episode narrates how Rama's wife, Sita, was found as an infant by King Janaka, then a hermit. He hid her in the ground and asked the deities to protect her. To retrieve her later, King Janaka ploughed a deep furrow (Plate 5). He thus named the infant, Sita, in reference to the furrow. The second story is from the life of the Buddha. It recounts how as young Prince Siddhartha he displayed supernatural traits at the annual ploughing ceremony held in his father's kingdom.

In the past the Ploughing Ceremony in Thailand was conducted by Brahmin priests only. During the reign of Rama IV (1850–67),

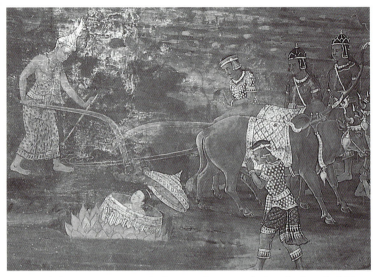

5. Mural showing King Janaka having the ground ploughed to find Sita. Grand Palace. (Sharon O'Toole)

this changed. As a devout Buddhist, King Mongkut added religious rites to the ceremony. Following the tradition of sowing the first rice in a royal field, the ceremony is held at the Pramane Ground, also known as Sanam Luang (Royal Ground), directly outside the Grand Palace. The lengthy ceremony may take up to two full days, the first dedicated to prayers and blessings, the second devoted to the actual ploughing.

As a ritual, the Ploughing Ceremony is concerned with predicting the forthcoming rice harvest. Will it be a bountiful year? Will there be enough rain in the coming season? Will the crops suffer from drought, floods, or pests? These are important factors the farmers want to know before the planting season begins. In response, the Ploughing Ceremony has been held. It was first observed in the Sukhothai period (1257–1350) and developed into an event of grand dimensions. The king led the lengthy procession while the Phya Raek Na (Lord of the Ceremony), as his representative, performed the ploughing rites. In the days of the Ayutthaya

22

kingdom (1350–1767) the Ploughing Ceremony declined in importance, and the king no longer participated in the ceremony, leaving the Lord of the Ceremony in charge of the event. The early Bangkok days (1782 onward) once again saw a lavish ceremony, introduced by Rama I but reduced to modest dimensions by Rama VI (King Vajiravudh), who also revived the Sukhothai tradition of personally appearing at the Ploughing Ceremony. Today, King Bhumibol or a member of the royal family attends the Ploughing Ceremony, still conducted by the Lord of the Ceremony.

Preparations for the Ploughing Ceremony involve a great number of details which are carried out carefully. The spacious Pramane Ground is transformed into a multi-pavilion shrine. But the once exclusive Brahmanical rites now share the first day with Buddhist prayers and rituals. In the afternoon monks place a Buddha image in one of the erected pavilions. During the same time Brahmin priests carry images of the Hindu gods Siva and Vishnu and place them in another pavilion, all in readiness for the second and main day of the ceremony.

It is also on the first day that the king appoints the Lord of the Ceremony. This position is customarily held by the Minister of Agriculture, called in the past as *Baladeba* or head of the department of lands. This 'temporary king' receives an item of the royal regalia, usually a ring, that empowers him for the duration of the ceremony. In earlier days, the sword of state was presented, bestowing on the king's representative a far greater power than he is given today. This allowed him to give orders and collect symbolic taxes from vessels that entered the harbour.

An important ritual on the eve of the Ploughing Ceremony is the blessing of the sacred rice to be used the next day. This Buddhist rite is performed by high-ranking monks in the Chapel Royal at the Temple of the Emerald Buddha, wherein an image of the Buddha 'Calling Down the Rain' is invited out. The king presides over the religious ceremonies and pours lustral water over the rice seeds, the sacred plough, the Lord of the Ceremony, and over the *nang thepi*, the young women who represent heavenly beings and who will carry the blessed rice seeds. Among the prayers chanted is the 'Monggol Gatha'. A sample reads as follows: '... Buddha, the

Dharma and the Sangha are precious Cause why seed which is sown grows up. May the seed sown this month grow well, may no misfortune occur to it' (Wells, 1975: 243–4).

The second day of the ceremony is the one everyone awaits. It is a colourful event wherein ceremonial drum bearers wearing elaborate red garments walk in procession, followed by Brahmin priests clad in white, the Lord of the Ceremony decked out in a white gem-studded tunic, and the young maidens dressed in traditional Thai attire. Adding to the drama of the day are the two white oxen harnessed to a crimson plough adorned with gold fittings (Colour Plate 12).

All the rites that follow are of great importance as they foretell the conditions of the elements to be expected in the coming year. The first ritual is the prediction of rainfall. The Lord of the Ceremony is offered three folded pieces of *phanung*, the loin cloth traditionally worn by Thai men. They are of three varied lengths, long, medium, and short, and are worn in three different ways. In the past, the crowds perceived the length of the *Baladeba*'s loin cloth as an omen for the coming rains; therefore, the choice of *phanung* will be indicative of the amount of rain to be expected during the year. A long loin cloth is a sign of a drought, its low hem nearly touching the ground, without any concern of it getting wet; the choice of a short *phanung*, which is worn above the knee, will assure a good supply of rain, perhaps even too much for the crops; and a medium-length cloth shows an average rainfall, the most favourable omen of the three.

Next is the ritual of ploughing the field. The entire procession enters an area marked by four bamboo fences decorated with flowers and leaves. It is led by the Lord of the Ceremony and the team of white oxen attached to the plough, followed by senior Brahmin priests with the four maidens just behind them, carrying silver and gold baskets filled with the blessed seeds on a pole over their shoulders. Drum and umbrella bearers complete the procession. The Lord of the Ceremony leads the sacred oxen nine times around the marked field, nine being an auspicious number in Thailand. In the first three rounds the earth is ploughed in three deep furrows. Then he scatters the new rice seeds into each

furrow. He completes the symbolic ploughing by walking around the furrows three more times as the new seeds are covered up. The Brahmin priests sprinkle lustral water, chant prayers, and blow conch shells as each round is completed.

Then comes the test for the success of next year's harvest. As the oxen halt, they are offered seven bowls holding rice, corn, beans, sesame seeds, grass, water, and wine. The crowd awaits nervously the choice of the oxen, and the fate of the future harvest. Any one of the grains, preferably rice, will assure a bountiful yield. A choice of water is a prediction of heavy rains and floods, and wine is altogether inauspicious.

At the end of this ritual comes the time for the farmers to get what they have been waiting for. The barriers are removed and they rush to pick up the rice seeds. These they will take back with them, to be mixed with their own rice seeds, with hopes for an exceptional crop. As the king retreats to the palace, many farmers remain behind, looking and digging the earth for the blessed grains of rice.

The Rocket Festival

The Bun Bang Fai, or the Rocket Festival, is a typical north-eastern village festival. It is a two-day affair which serves a social purpose besides appealing for rain. It is an occasion for the entire village to gather where social bonds are reaffirmed. It is a time for socializing, and for releasing pent-up energy. The festival also serves to assure the villagers that pacifying the elements of nature will prove beneficial for their personal well-being. None the less, the need to propitiate the rain god is strong, and the festivities are reckless. Like in neighbouring Laos, Buddhist rites have been intertwined with old folk practices, with acts of merit followed by carousing, dancing, and of course, the launching of the sky-rockets (Plate 6).

Because of the importance of the festival in its attempt to bring rain, much time and effort are dedicated to creating powerful rockets. Every village produces its own rockets under the guidance of Buddhist monks, the latter holding the secret formula for the explosives that propel the rockets. In preparation for the event, rockets are decorated, launching platforms are built, and

lively processions set the mood for the festivities.

Sky-rocket festivals take place weekly in small villages in the north-east during the months of May and June. The best known is the colourful festival in the town of Yasothorn. There, the large rockets are lavishly decorated, some displaying true works of art (Colour Plate 13). Many villages join the exciting competition hoping for their rocket to soar highest thus ensuring plenty of rain and good fortune for their village. The rockets are classified loosely according to their size and the amount of explosive each can hold. These measure from 2 to 9 metres in length and hold anywhere between 4 and 20 kilograms of gunpowder. In the past, the grand rockets were made of hollow bamboo and held as much as 100 kilograms of explosives. In some cases these were replaced by metal pipes. More recently, plastic-based pipes have been introduced as the 'modern' material for the sky-rockets.

6. A young north-eastern dancer at the Rocket Festival. (Ruth Gerson)

Several legends surround the origin of the festival. All are concerned with rain and symbolic beings, such as *naga*, the guardians of the underground waters. Some believe that rockets will please Wassakam, the god of rain. More popular is the belief that farmers must appeal to Phya Taen, god of the sky and please him by firing rockets, to which he will surely respond favourably by releasing his

semen in the form of rain which will fertilize the earth. With this in mind, the festival becomes very male-oriented, with young men carrying a red-tipped wooden phallus in their hands to poke jokingly at young women. Copulating wooden figures are assisted by villagers, often by children, who pull strings that activate the act, all as part of the fertility rites.

It is believed that the Bun Bang Fai had its beginnings with the legend of Pa Daeng and Nang Ai. Nang Ai's father was a king in a remote region of the north-east where drought had plagued his land. To restore the prosperity of his kingdom, the king attempted to appeal to the rain god by offering him fire. He called for a contest of rockets, offering his beautiful daughter, Nang Ai, as the prize for the winner. It was Pa Daeng's rocket that soared highest into the air, and he won her hand.

The young couple did not live happily ever after. The *naga* king's son, Suwanna Phangkhi, fell in love with Nang Ai and he too wanted to win her hand. Born a snake, he turned himself into a young man so he could watch the contest and Nang Ai. When Nang Ai married Pa Daeng, the lovesick *naga* was determined to remain near Nang Ai. So he changed himself into a white squirrel, sat outside her window, and continued watching her. Nang Ai noticed the squirrel and ordered it caught but instead, the white squirrel was killed and its meat eaten. The *naga* king avenged his son's death by destroying the kingdom, turning it into a marsh from which the young couple tried to escape on horseback. To commemorate this legend, a real or a papier mâché horse, with a young couple on its back, is led in present-day parades as is the huge man-made white squirrel.

It is considered auspicious if rain comes following the first day's prayers, and the second day's rocket launching, as it often does. Like in most Thai festivals, there are contests for the best dance group, representing a school, temple, or a village; the female dancers led by vigorous male drummers. In Yasothorn, the rockets are paraded in the streets. Many are magnificent contraptions shaped like the *naga*, with their 'heads' rearing, symbolizing the much-needed water.

The rockets are launched from either tall trees with bamboo

scaffolding, or metal stands situated for safety in the middle of a field (Plate 7). The first rocket is a portent of the season's forthcoming rain. It must shoot up straight. All subsequent rockets are part of the contest with the one lasting the longest being the

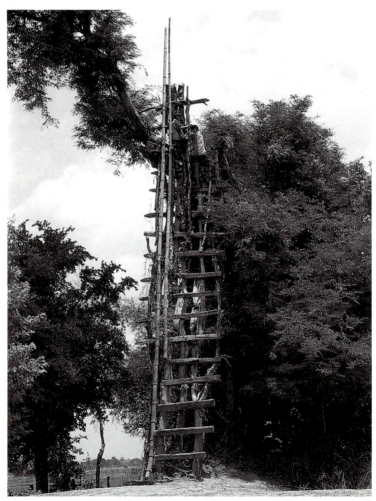

7. A rural rocket launcher. (Ruth Gerson)

winner. Losers do not get away easily as their failure to win deprives their village of good fortune. They are therefore thrown into the mud, a fate believed to be deserved.

The Ghost Festival

Several weeks after the Yasothorn Rocket Festival, the most unusual of all festivals in Thailand takes place. Although its aim is to bring rain and ensure the fertility of the earth, this event is also a coming of age rite, with the ghosts being portrayed by boys and young men (Plate 8). The name Phi Ta Khon translates as 'masked ghosts' but the festival re-enacts a scene from one of the Buddha's former lives thus blending Buddhism and animism. It recounts the return of Prince Vessantara to his city after years of exile, a favourite tale in Thailand. It was said that the entire city came to meet Vessantara upon his return and even the ghosts could not resist joining in the festivities. The result is a most wonderful and lively celebration.

This unique festival takes place at the beginning of the rainy season, around late May or June, at the village of Dan Sai, nestled in a remote valley of the mountainous Loei province. Unlike other north-eastern festivals which take place in several locations, the Ghost Festival can be seen in Dan Sai only. No other place in Thailand or its neighbouring countries celebrates anything like it.

Traditionally, the date for this festival was chosen during Visaka Bucha. However, the need to conform to contemporary life brought changes in a number of areas, including the timing of this festival. Today it is held on a weekend as the young boys who participate have to attend school during the week. Like many other festivals in Thailand, its duration has been reduced from three to two days.

An important figure in the village and in the Ghost Festival is the Chao Pho Kuan, the village male medium who communicates the wishes of the village spirit to the villagers, including the date of the festival. Dressed in white with his long hair wrapped in a turban, he is much respected and feared in the village. Another significant person is the Chao Mae Nang Tiem, the female

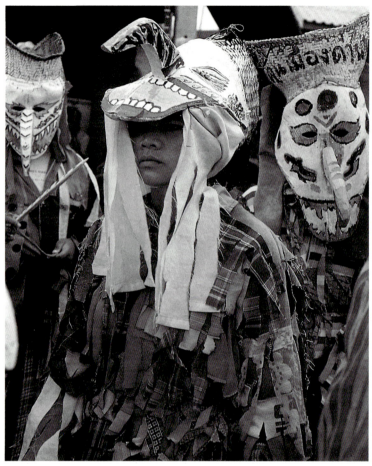

8. Young boy at the Ghost Festival. (Ruth Gerson)

medium who assists with the ceremonies. Other important persons in the festival are four monks who give a Buddhist touch to the affair, and the head of the ceremony, the Phra Uppakut. Male helpers and followers, known as *saen*, assist the Chao Pho Kuan throughout the festival.

The festival rituals begin before dawn of the first day. The

village medium and the *saen* head to the Mun River to collect smooth and perfect white pebbles from the river bed. These they take to Wat Pon Chai, the village temple, and place them on the four pedestal shrines situated at the four directions of the wind, along with other prescribed offerings. From the temple the procession moves to the home of the Chao Pho Kuan for the traditional north-eastern ceremony of *bai si*, the tying of blessed white cords on the wrist. In most *bai si* ceremonies each person receives a cord on his wrist, but here the participants tie the blessed strings on the outstretched arms of the Chao Pho Kuan. Prayers and food follow as 'ghosts' start to gather for the main procession of the festival.

The procession comprises of humans and an assortment of 'spirits' and 'ghosts'. It begins with several competing groups of dancers and drummers beautifully attired in various styles of north-eastern outfits. They are followed by the boisterous and jovial 'ghosts' which increase in number as the procession gets under way. To accentuate and dramatize the occasion, 'forest dwellers', covered with large leaves to indicate their habitat, join the procession. Also paraded in the procession are enormous papier mâché figures of several couples representing fertility, the male with a string-operated phallus (Colour Plate 14). Papier mâché buffaloes pulling a plough show that the earth is ready for tilling, another way of depicting fertility. A weird and almost petrifying sight is that of the 'mud people' (Colour Plate 15). They too, whose spectral appearance resemble risen corpses, affirm the joy shared by everyone at Prince Vessantara's return. This is after all a spirit festival, and every form of ghoul is welcome. This mixture of colours and sounds can be quite heady.

Although every 'ghost' adds a personal touch to its attire, there appears to be prescribed details common to all. The mask, the main item of the costume, is made from the base of a coconut stalk. It is naturally curved and lends itself to this purpose. The holes for the eyes are cut out and a stiff elephant trunk fashioned from thin wood is added as a nose. The entire surface of the mask is artistically decorated, a feat which often takes several weeks. The mask is topped by a large tiara-like contraption made of local baskets commonly used for storing glutinous rice, a food distinct to

the region. The 'tiara', too, is richly decorated and ends on each side with pointed 'horns' (Colour Plate 16). The 'ghosts' carry gourds, the symbol of the much-desired water, and buffalo bells are tied to the lower part of their backs jingling loudly to accentuate their frightening appearance. While the garments vary according to personal choice, they often carry wooden swords rounded like a phallus, or dangle the female fertility symbol from bamboo fishing poles. The 'ghosts' chase the young women and poke the phallus at them. The women look embarrassed but seem to take delight in the game. The elder women do not let the men rule the day. They join the procession carrying fishing nets with which they try to snag a wooden phallus, and fishing baskets in which they stow away their catch. The procession on the first day ends at the town hall where prizes are given to outstanding participants.

The second day's festivities do not start until early afternoon. As most of the male villagers are thoroughly inebriated from the previous day's revelry, one can comprehend the reason. The second day is a day for acquiring merit, one of twelve such days traditional to the north-east. Shortly after noon the Chao Pho Kuan, Chao Mae Nang Tiem, the Phra Uppakut, and the four monks meet at a crossroads at the edge of the village where a Buddhist ceremony takes place. When the praying ends, the festival reverts once again to its lively and even humorous rituals. The Chao Pho Kuan is lifted on to a palanquin-like litter, which in fact comprises of skyrockets that will be fired at the end of the day. He carries a bowl filled with coins covered in silver and gold paper which he generously throws into the crowd as the procession moves on. He, on the other hand, is jostled and tossed on his uneasy perch in a good-humoured and fun-loving way. The head of the ceremony and the four monks are subjected to similar treatment. With the *saen* they head for Wat Pon Chai followed by the 'ghosts'. Also in the parade are 'Prince Vessantara' and his wife 'Madi', carried with great pomp back to their domain.

Once inside the temple compound, the procession rounds the main sanctuary three times bearing counter-clockwise as in funerals. This unusual direction might seem alarming to the observer. It is, however, the cycle that 'ghosts' must take as they are no longer

considered to be among the living. This is followed by the firing of sky-rockets from a tall tree behind the temple. The first rocket launched is that of the Chao Pho Kuan followed by that of the Chao Mae Nang Tiem and all others. Like in rocket festivals of the preceding weeks, a rocket that soars high into the sky ensures good rainfall and abundant harvest in the coming season. The evening ends with the reading of the 'Tessana Mahachat' in the temple, the famous sermon known as 'The Great Life', which recounts the previous human incarnation of the Buddha as Prince Vessantara. This wonderful festival is the last of the rain ceremonies, heralding the true start of the rainy season.

4
Traditional Cultural Festivals

ALTHOUGH most festivals in Thailand originated in India they have become part of the Thai cultural heritage. Many are supplications to deities for favours to be bestowed upon them. The Songkran rites express people's desire to secure a good year for themselves; the Swing Ceremony, like the agricultural festivals, appeals for plentiful rain to ensure a bountiful harvest, while the Loy Krathong festivities honour all sources of water, asking for forgiveness for polluting them. Buddhist, Hindu, and animist deities are propitiated in rituals based on ancient practices and beliefs.

Songkran

Songkran is the focal holiday of Thai culture, marking the change of seasons from arid heat to humid rains. The customary three days of celebrations embrace the rites of spring, family gatherings honouring the elderly, acts of purification, Buddhists rituals, and the now very popular water-splashing revelry.

The name Songkran is derived from ancient Sanskrit literally describing the sun's monthly movement within the zodiac. In April, the sun leaves the sphere of Aries and enters that of Taurus, a period known as Maha Songkran or the Great Songkran. The festival of Songkran was most likely introduced into Thailand from India where the festival of Holi is still celebrated. The theme of water splashing during the hot season has been so well integrated in South-East Asian cultures that most countries neighbouring Thailand have their own water festivals, from the south-western province of Yunnan in China, to Laos, Cambodia, and Burma. The purpose of water is manifold, as it is used for cooling, for symbolizing the act of purification, and for invoking the life-giving monsoon rains.

Originally a lunar holiday, Songkran has become a fixed date on

the Thai calendar, observed from 13 to 15 April, to suit modern life. Although parts of Thailand celebrate Songkran up to one week, most regions observe the traditional three days. On the eve of Songkran, every house is thoroughly cleaned and old refuse is burned so as not to carry bad luck or anything harmful into the new year, with hopes of starting everything afresh. Another old tradition is the setting off of firecrackers to frighten away any bad spirits that may lurk about from the old year. This day is known as Tarusa Suta Pi, the last day of the old year. Wan Songkran or Songkran Day, the first day of the year, is also known as Wan Thaloeng Sok. This day was believed to have been the peak of the hot season when the hours of the day and night were equally divided.

Early in the morning of Songkran Day people pay respects to the monks by bringing offerings of food prepared the previous day. This is customarily a temple ritual which enables the public to acquire merit. In recent years hundreds of monks now gather at the Pramane Ground to receive alms as the city of Bangkok has grown populous. Special food served during this holiday is *khao che*, cooked rice soaked in cold aromatic water, while in northern Thailand glutinous rice cakes are offered.

In the early afternoon, Buddha images are taken out of temples for ritual bathing, and are sprinkled with lustral water by devotees. A most revered image in Bangkok is the Phra Phuttha Sihing, housed in the National Museum's Buddhaisawan Chapel. The image is taken out to the Pramane Ground every year for the public to pay their respects (Plate 9). Before placing the image in the elevated pavilion erected for the purpose, it is carried around the city to allow a greater number of people to receive merit. Once in place, the image is sprinkled by thousands of people who also free birds from their cages and release fish into rivers so as to gain additional merit and good fortune. The act of purification is also performed on images in private home shrines, on family elders, and on specially revered monks and village elders who are father figures to their communities. Songkran is a time for family gatherings, when young members bringing gifts, visit their elders, pour scented water over the palms of their hands, and receive blessings in return. In the past, these respected elderly relatives were bathed and dressed

9. The Phra Phuttha Sihing being sprinkled with lustral water by devotees as a form of respect. Pramane Ground. (Ruth Gerson)

in new garments brought as gifts for the new year. The gentle water sprinkling done within families escalates into public splashing by the bucketful. No one is spared a generous douse of water in this mischievous merriment and all participate good-naturedly.

Many of the lively festivities begin on the first day of Songkran. In the afternoon, groups of young men and women play old courting games believed to be a vestige of an ancient culture and referred to by some scholars as 'mating games'. One such game still widely played in Thailand today is the game of *saba*, in which both sexes participate (Plate 10). Generally girls of one village play with boys from another village as this flirtatious game often leads to marriage. They sit opposite each other in a small, enclosed arena and take turns in carrying a flat, rounded piece of wood on one foot while hopping on the other. The object of the game is to knock down a similar piece of wood, perched on its side, in front of a person of the opposite sex. Both success and failure elicit further flirting and teasing.

Songkran serves a multitude of religious and social functions. Its festivals are celebrated with great zest, including parades, carnivals, and beauty contests, while music blares and great quantities of food and rice liquor are consumed. On the first afternoon, a Nang Songkran or Miss Songkran is chosen to reign over the festival. She is led in procession seated on an animal figure representing the day of the week on which Wan Songkran falls that year. There are seven such animals. The Garuda, for example, stands for Sunday while a tiger is for Monday. These figures derive from an ancient Hindu legend telling of a god who had lost a bet and in the process also lost his head. His seven daughters ensured that his memory lived on by parading his head once a year. This procession still continues as part of the Songkran festival; the severed head, however, has been replaced by seven creatures, each corresponding to one of the god's daughters.

A tradition practised on the second day of Songkran is the building of sand *chedi*. Although predominantly a northern custom, sand *chedi* have become a popular way of devotion in many regions of Thailand. A sacred structure, the *chedi* symbolizes the place where the Buddha's ashes were kept. Wealthy people often add new

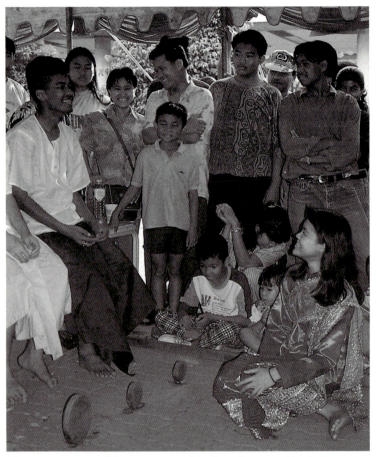

10. Young men and women engaged in the *saba* game. (Ruth Gerson)

structures to a temple compound usually in the form of a *chedi*. The poor emulate this act of merit by constructing a representation of a *chedi*, a small one made of sand, in a designated area of the temple. As in permanent *chedi*, small items such as coins, *bodhi* leaves, and Buddha images are placed in the core of the sand *chedi*. Likewise, these tiny structures are decorated with colourful flags, topped by candles, incense sticks, and flowers. The completed sand

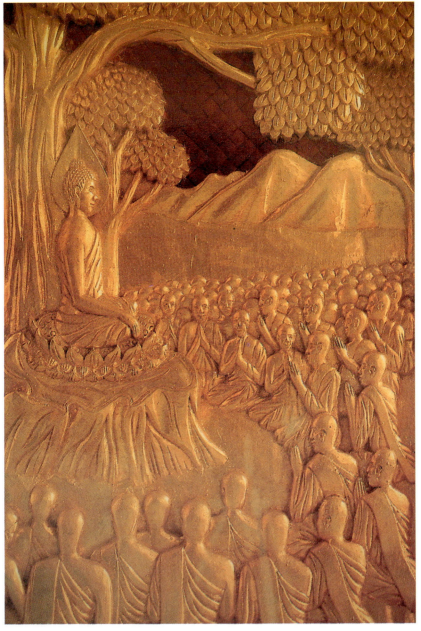

1. Gilded woodcarving depicting the spontaneous gathering of 1,250 monks who came to hear the Buddha preach. (National Museum Volunteers' collection)

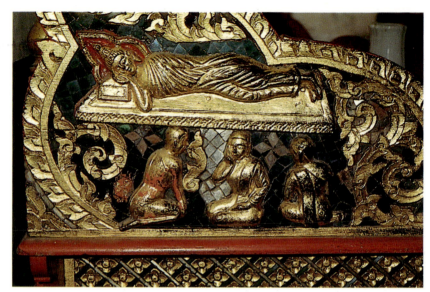

2. The Buddha entering nirvana, detail from an abbot's chair. Wat Daowading, Thonburi. (Sharon O'Toole)

3. Monks circumambulating an ancient temple on Asalaha Bucha. (Elizabeth Dhé)

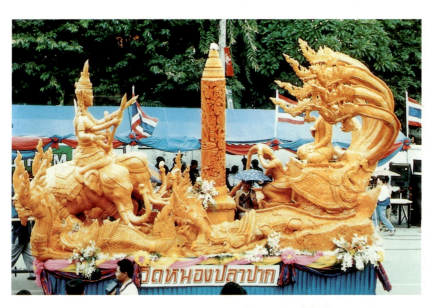

4. Large wax candles on a float at the Candle Procession in Ubon, depicting the Buddha under the *naga* on the right and Indra on the Erawan on the left. (Sally Lavin)

5. Large *naga*-shaped candle at the Candle Procession in Ubon. (Sally Lavin)

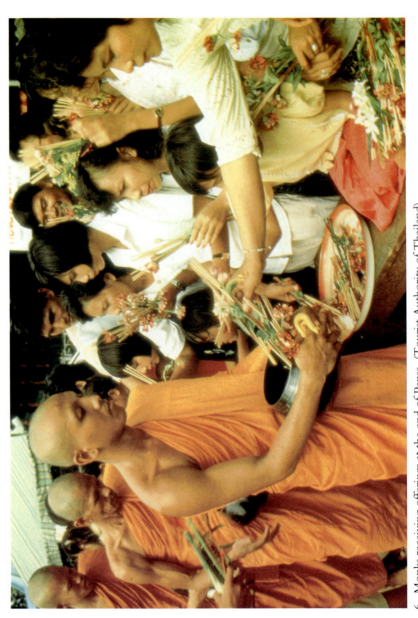

6. Monks receiving offerings at the end of Pansa. (Tourist Authority of Thailand)

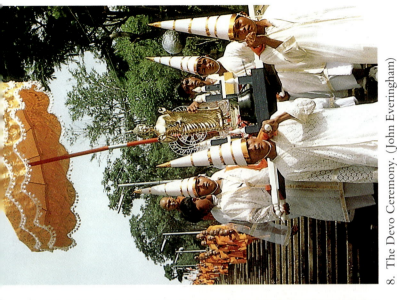

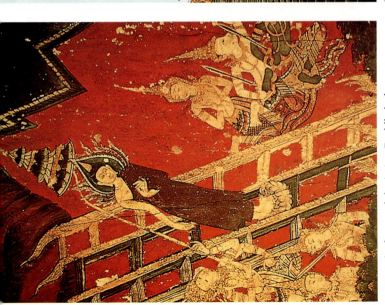

7. Detail of a mural depicting Buddha's descent from Tavatimsa Heaven. Buddhaisawan Chapel, National Museum, Bangkok. (National Museum, Bangkok)

8. The Devo Ceremony. (John Everingham)

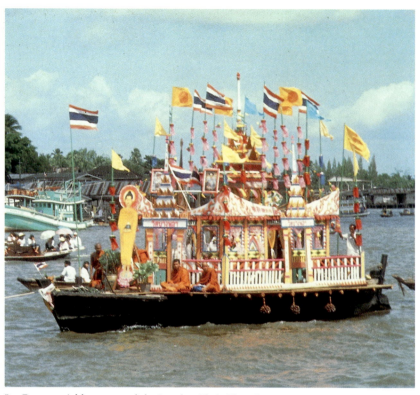

9. Ceremonial boat towed during the Chak Phra Ceremony in Surat Thani. (Tourist Authority of Thailand)

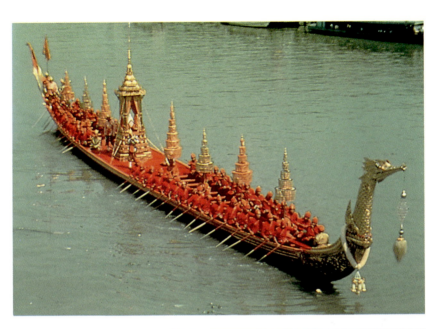

10. *Suphanahongs*, the king's barge, during the Royal Barge Procession. (Tourist Authority of Thailand)

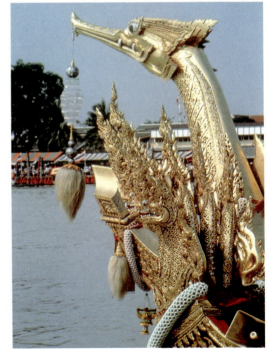

11. The prow of the *Suphanahongs* with the crystal tassel suspended from the golden swan's beak. (Tourist Authority of Thailand)

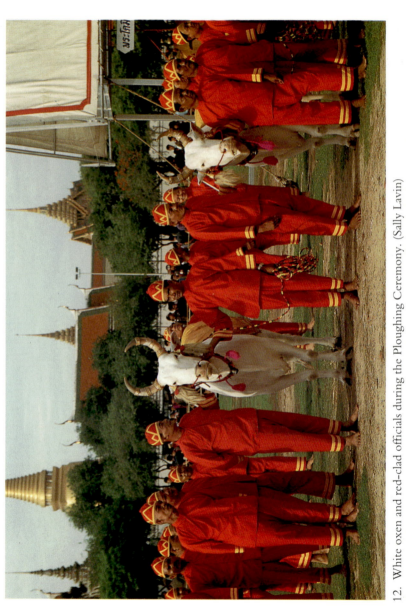

12. White oxen and red-clad officials during the Ploughing Ceremony. (Sally Lavin)

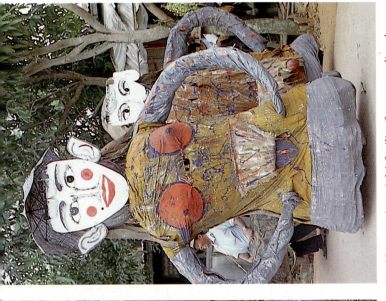

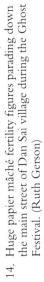

14. Huge papier mâché fertility figures parading down the main street of Dan Sai village during the Ghost Festival. (Ruth Gerson)

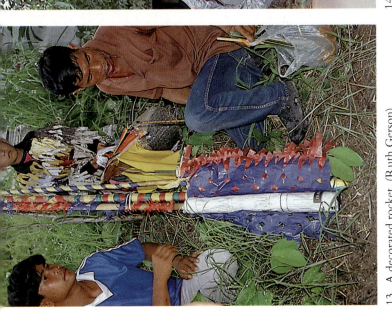

13. A decorated rocket. (Ruth Gerson)

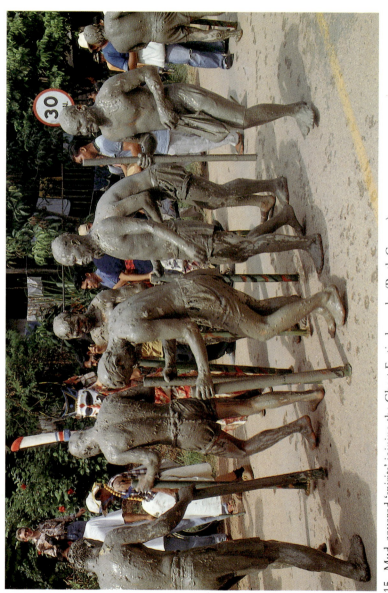

15. Mud-covered 'spirits' joining the Ghost Festival parade. (Ruth Gerson)

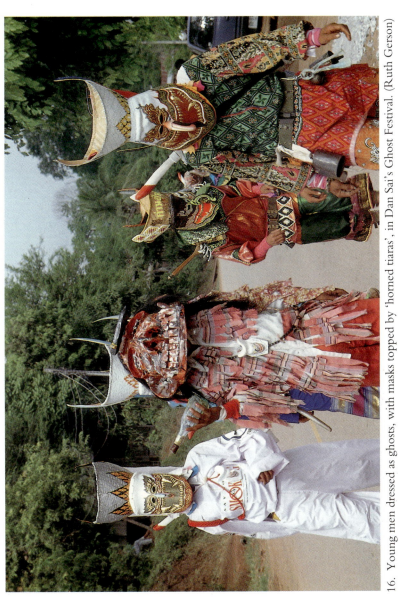

16. Young men dressed as ghosts, with masks topped by 'horned tiaras', in Dan Sai's Ghost Festival. (Ruth Gerson)

17. A colourful *krathong*.
(Ruth Gerson)

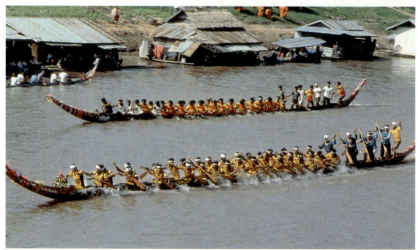

18. Boat races on the Nan River. (Tourist Authority of Thailand)

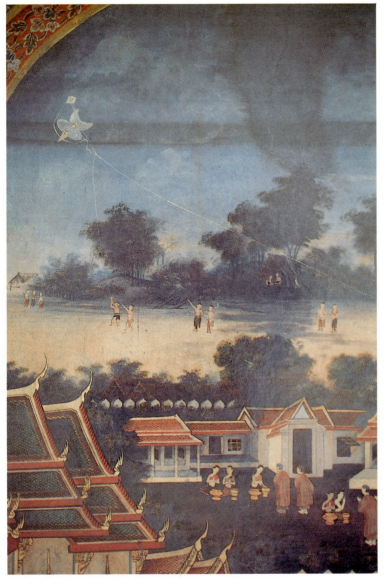

19. A nineteenth-century mural depicting kite fighting. Wat Rajapradit, Bangkok. (Walter Unger)

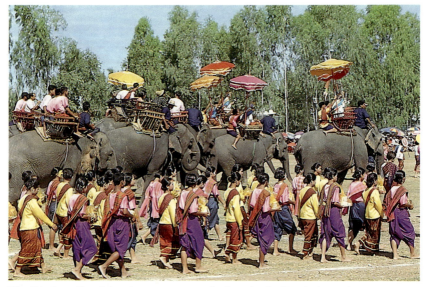

20. Display of traditional ceremony on elephant back. (Ruth Gerson)

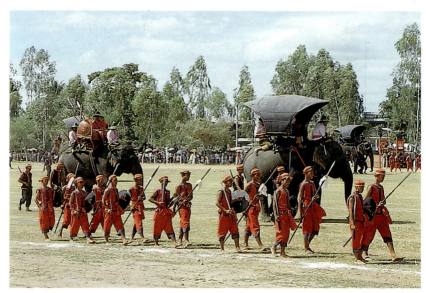

21. A procession of royal display in the Elephant Round Up in Surin.
(Ruth Gerson)

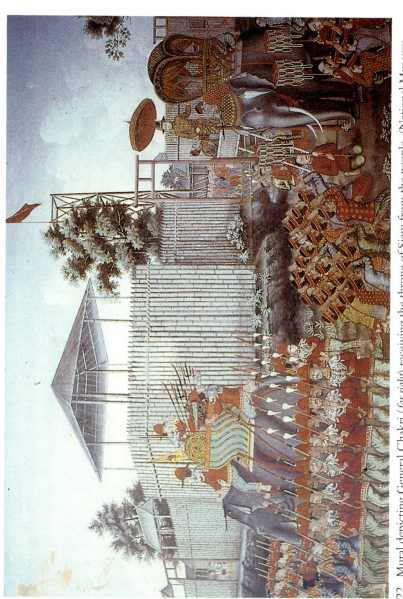

22. Mural depicting General Chakri (*far right*) receiving the throne of Siam from the people. (National Museum Volunteers)

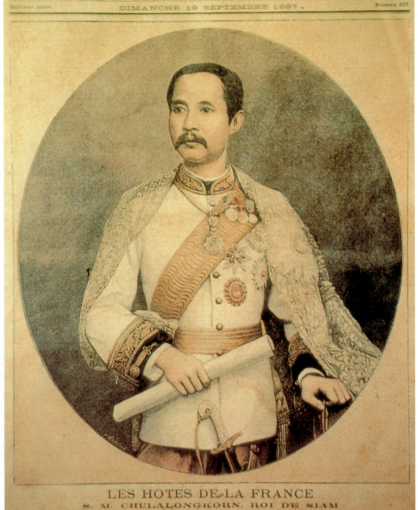

Le Petit Journal

SUPPLÉMENT ILLUSTRÉ

Huit pages : CINQ centimes

DIMANCHE 19 SEPTEMBRE 1897

LES HOTES DE LA FRANCE

S. M. CHULALONGKORN, ROI DE SIAM

23. A sketch of King Chulalongkorn on the cover of *Le Petit Journal*, Paris, 10 September 1897.

chedi are sprinkled with scented water and some temples award prizes to the most beautiful ones. This custom is also a symbolic replacement of sand which may have clung to devotees' shoes and inadvertently carried out of the temple. The Songkran festival goes on for several days, a welcome respite from work and daily routines, and a temporary diversion from the summer heat.

The Swing Ceremony

Lo Ching Cha

In a wide clearing, in the heart of old Bangkok, stands a most imposing structure, the frame of the giant swing known in Thai as Sao Ching Cha or 'the posts of the swing'. These red painted posts soar an impressive 30 metres skyward, and bear testimony to an unusual festival which used to be held in the past. Built by Rama I in 1784 in the belief that this symbolic structure would strengthen his country, the swing was destined to undergo several renovations in later years. In 1920 the ageing teak posts were replaced, paid for by the Louis T. Leonowens Company, and in 1947 a destructive fire erupted, ignited by sparks from burning incense. An order was given to dismantle this unsafe structure, but public uproar saved the swing which required further repairs. Final work was carried out in 1972, reinforcing once again a landmark which links the past with the present.

The Lo Ching Cha (Giant Swing Ceremony) which originated from southern India was a fifteen-day celebration held in the middle of the second lunar month, usually in early January. The ceremony and its rituals were conducted solely by Brahmin priests. This festival became known as the 'Reception of the Gods', to honour the Hindu gods' annual visit to earth. The first to descend from his heavenly abode is believed to be the god Siva, known in Thai as Phra Isuan. He visits earth for ten days during which a number of ceremonies and celebrations are held in homage. As god of fertility in the Hindu pantheon, Siva symbolizes the power of procreation in humans and animals, and is the force that endows

the earth with good harvest. Thus the festival was an appeal for abundant rainfall in the approaching monsoon season.

Siva is received with great festivity, highlighted by the daring yet entertaining Swing Ceremony, as it is known that he is fond of swinging in the heavens with his wife Uma. Legend tells that Uma, looking down on earth, saw lovers swinging leisurely and begged Siva to build a swing for her. Consenting, the god entwined two *naga*, on which the celestial couple proceeded to swing with great energy, oblivious that their delightful swinging shook the heavens and induced torrential rains that nearly drowned the earth. Alerted by other gods, Siva ceased his swinging but decided that this 'game' be held once a year to induce rain, thus linking his name to the Swing Ceremony.

Being a harvest-related festival, the Minister of Agriculture received the great honour of personifying the god Siva, acting as Lord of the Swing Ceremony during celebrations in the past. Attired to represent the god, he was carried in a palanquin to the site of the ceremony. There he sat in an ascribed position, keeping his right foot on his left knee, occasionally shifting this pose around. He kept this stance throughout the ceremony to prevent both of his feet from touching the ground, a posture likely to bring disaster upon the kingdom To lessen the burden of this role which befell the Minister of Agriculture annually, Rama IV assigned the nobility and high-ranking officials, a custom continued by successive monarchs.

During Siva's ten-day visit to earth, he is believed to be accompanied by a retinue of several lesser deities. They are Phra Athit the sun, Phra Chan the moon, Mae Toranee the mother earth, and Mae Khongkha the goddess of the waters, depicted in carved relief on a wooden panel from the Brahmin Temple near the giant swing. The invitation for Siva to descend to earth from his abode on Mount Kailasa is issued by Brahmin priests, the only ones who may contact the god directly. Dressed in white robes embroidered in gold, they intone the simple invocation from 'The Opening of the Kailasa Gates' (Plion-Bernier, 1973: 56).

Siva's descent to earth is supported by the legend that he wanted to test the durability of the world created by the god Brahma. Not

certain whether the world would crumble under his weight, Siva extended one leg carefully down to earth, hence the one-legged stance in later re-enactments of the god's visit. He then tested the sturdiness of the mountains by attaching them to *naga* who pulled in opposite directions. The earth and the mountains withstood the stress test, later represented by the poles of the swing, while the ropes symbolized the attached *naga*.

The Giant Swing Ceremony was held twice during each of Siva's visits. The first took place during the morning hours, a few days after the god's descent to earth; the second, in the afternoon, two days later. The swinging was performed by groups of four young men, each team repeating three times. Referred to in Thai as *naliwan*, the men were dressed and hooded to resemble the mythical *naga*. They climbed on to the flat board of the swing, suspended from the carved cross-beam high above the ground. There, the *naliwan* hung perilously, as they hailed Siva with a *wai*, the traditional Thai greeting, by raising their clasped hands to their foreheads. Then the rocking began with someone on the ground pulling a rope, and within minutes the *naliwan* took over, pushing the swing higher and higher. At a short distance from the swing, a slim bamboo pole was fixed, with a purse of money tied to its top. It was the task of the young man seated at the front to grab the purse with his teeth. Removing the *naga* hood, he would strain for the prize which was barely within his reach, while the three *naliwan* continued to swing and control the movements of the board. This dangerous feat would elicit vocal reactions from the crowd below; a failed attempt was met with jeers while a successful one was resoundingly cheered, accompanied by the sounds of gongs and conch shells. The young men were allowed to keep the hard-earned money, with a 12-baht purse for the first swinging, 10 for the second, and 8 for the last. At times disaster marred these festivities when a young man fell to his death in his attempt to catch the purse. Such an accident was regarded a bad omen for the kingdom.

The Swing Ceremony ended with the *naga* dance, following the second swinging session. The *naliwan* of the three teams, still in *naga* costumes, sprinkled lustral water on themselves and each other

in a haunting ritual dance, symbolic of the much-awaited rainfall. After further ceremonies in the Brahmin Temple, Siva was sent off with the blessing of the Brahmin priests intoning 'The Closing of the Kailasa Gates', knowing that a year would pass before the god would visit earth again.

Cha Hongse

While the Giant Swing Ceremony dominated the area around the Brahmin Temple, a less noticeable one took place within its precincts; but unlike the Giant Swing Ceremony which was discontinued, the Cha Hongse (Swan Swing Ceremony) still takes place every January. In fact, the outdoor colourful swinging was part of what is known as Triyampavai Tripavai, ceremonies expressing appreciation to the gods for providing good harvest, and which is performed during the fifteen days of the gods' visit to earth. Siva's descent is noted with the Triyampavai rites, from his arrival to his departure ten days later on the full moon. Before Siva's return to his celestial abode, the god Vishnu also descends to earth for a five-day visit and duly honoured with the Tripavai ceremony.

Brahmin priests prepare for the reception of the gods on the eve of the festival by taking a ritual bath and vowing to abstain from certain practices. The Phra Maha Raja Guru, a high-ranking priest, presides over the ceremonies, and is the one who invites the gods to visit; all other rites are performed by the head priest. The Hindu gods are given due homage at the altar by an array of offerings. The main item is popcorn, resembling heavenly food in its whiteness, formed into small heaps on top of which offerings of fruits such as bananas and coconuts are placed. Some coconuts are placed under the table, while sugar-cane lines the side walls, all indicative of the recent harvest. The head priest consecrates the fruit offerings with lustral water, and carries to the altar a bell and a lit candelabra for the fire-purifying ritual, accompanied by a recitation of mantras and the cacophony of conch shells. With this rite devotees attempt to get the gods' attention to focus on them.

Siva's departure is dramatic, befitting the god's general demeanour. The Naresvara Procession, named after the god's ancient

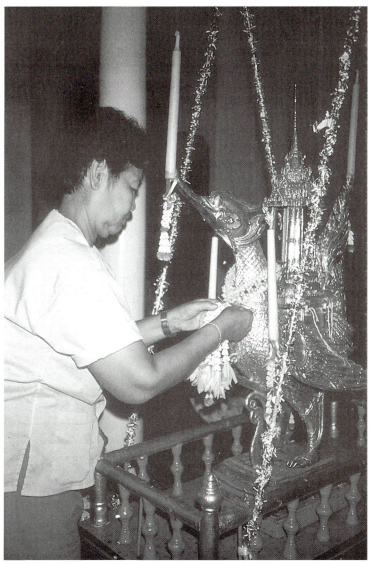

11. The *hongse* on a miniature swing during the Swan Swing Ceremony in the Brahmin Temple. (Monique Heitmann)

name, winds its way from the Brahmin Temple to the Grand
Palace, where the king presents the priests with images of Siva, his
wife Uma, and their son Ganesha. These are carried back to the
temple and bathed ritually for their return journey to their celestial
abode. The heavenly swan, known in Thailand as *hongse*, is placed
in a cradle-like seat, suspended from a miniature replica of the
Giant Swing (Plate 11). To the sound of mantras, the gods, the
swan, and the rock symbolizing Mount Kailasa are purified with
sacred water and by the fire ritual. The high priest blesses the
hongse, fixes a lit candle on its beak and places the gods gently on its
back for the homeward journey. He then alerts the heavens of
Siva's return by ringing a bell, joined by the deafening sound of the
conches. The swan rocks gently to the glow of candles as it faces the
symbolic mountain, and the heavenly family is sent off ceremoni-
ously. The remaining lustral water is sprinkled on those attending
the ceremony, and the rites of the Cha Hongse come to an end.
The next five days are dedicated to Vishnu with daily offerings but
omitting the festivities that surround Siva's visit. At the end of
Vishnu's sojourn, his image is carried back to the palace to remain
until the next Triyampavai Tripavai ceremonies.

Loy Krathong

One month after end of Pansa, on the full moon of the twelfth
lunar month, usually in November, people throughout the land
head to rivers, ponds, and canals to float their *krathong*. A *krathong* is
a floating offering traditionally made of banana or plantain leaves
to form a cup-like receptacle in the shape of a lotus flower (Colour
Plate 17). *Loy* in Thai means 'to float', hence the name of this pop-
ular and impressive festival, Loy Krathong, 'to float one's offering'.
These offerings, set afloat upon the water, are sent to Mae
Khongkha, the goddess of the waters, to appease and ask her for-
giveness for abusing and polluting the water throughout the year.
As a life-giving source, water should be treated with care. Despite
its importance and utility, many sources of water are polluted by
industry and by other careless means. This issue was recognized by
the people of ancient India who worshipped the goddess of the

Ganges as the giver of life, a concept which reached Thailand's kingdom of Sukhothai about 700 years ago, where the name Ganges was pronounced as Khongkha.

Most Thai holidays and festivals evolved from ancient legends, and Loy Krathong follows that tradition. It was told that this ceremony of offering first appeared in the reign of a great Sukhothai ruler, believed to have been King Ramkhamhaeng. It began when a young maiden by the name of Nang Nopamas wished to honour the water spirits during the festivities which marked the end of the rainy season. The daughter of a Brahmin priest at the King's court, she followed her father's tradition by making a delicate float to offer to Mae Khongkha. It was Nang Nopamas who first crafted a float in the shape of an open lotus flower. As an act of respect, she offered the *krathong* to the King, who accepted and floated it down the river. This attractive manner of offering greatly appealed to the people of Sukhothai, who repeated the festival annually. In time it became integrated into Thai culture, perpetuated for centuries to this day. The legendary Nang Nopamas is represented each year by a beautiful young woman, selected to reign over the festivities, a practice particularly popular at universities. In recent years the Loy Krathong festival has been reintroduced to ancient Sukhothai, where the old ruins are set aglow by the light of thousands of candles.

Traditional *krathong* are still in the shape of a lotus, made of banana leaves and decorated with flowers. Over the years competitions for the most beautiful *krathong* have been held, and new shapes have appeared such as birds, boats, and other imaginative subjects. For colourful effects, artificial materials are applied, a use frowned upon in this environmentally conscious age. Always present in a *krathong* are flowers, lit candles, and incense sticks (Plate 12). Occasionally, coloured paper flags are added, flapping festively in the gentle breeze. Another optional item is a coin, tucked in the *krathong*'s greenery. Coins were symbolic offerings to the water spirits, but in recent years they have been regarded as donation to the poor, who often search the floats for coins.

Although Loy Krathong is not considered a religious festival, its origins are intertwined with ancient beliefs. Foremost, it is an

12. Members of a family prepare to float their *krathong* on the river during the Loy Krathong Festival. (Ruth Gerson)

animistic celebration to honour the water spirits. Additionally, it relates to the Chinese River Festival when candles are lit on floats to guide home the spirits of people who have drowned. This also coincides with India's Diwali Festival, when thousands of sparkling lights commemorate Rama and Sita's return to Ayodhya. Loy

Krathong also has strong Buddhist overtones, relating to a specific episode in the last life of the Buddha. It was told that the Buddha, before attaining enlightenment meditated days at a time, ignoring the meagre meals that were to sustain him. On one such occasion, the maiden Suchada noticed him sitting immobile under a tree, and recognized the aura around him as that of a great man. She rushed home to prepare a nourishing meal which she offered to him in a golden bowl. Gotama the Ascetic, as he was known then, cast the bowl upstream, against the strong current, in a quest to learn whether he would indeed be enlightened one day. The bowl's floating upriver in defiance of nature was the affirmative sign he had been looking for. The bowl drifted until it ultimately sank and landed on the *naga* king. At first annoyed at the disturbance, the serpent soon recognized the bowl as that of the future Buddha, and rising from the waters he begged Gotama to press his foot in the sand, leaving its print there for eternity. Consequently, when people set their floats upon the water, they pay tribute to.the Buddha, the golden bowl, and the footprint, while honouring Mae Khongkha, the goddess of the waters.

There is yet another reason for floating a *krathong* on the water, a feature common to many cultures. People believe that with proper prayers and offerings they can rid themselves of their sins. Centuries ago, large *krathong* were designed for the purpose of sending one's garments down the river as a physical act of removing and sending away all transgressions. Whatever reason, purpose, or belief is attached to a *krathong*, it remains a favourite way of propitiating the forces of nature and religion alike.

5
Sporting Festivals

FESTIVALS, in which physically demanding activities take place, have become part of the Thai calendar. Originally used in warfare, boat racing, kite flying, and elephant training have become sporting events, requiring great skill and accuracy. These events are performed in impressive teamwork, when men attune their strength to act as one, while a different kind of teamwork is displayed by the elephants and their trainers.

Boat Races

As the monsoon rains stop and Pansa comes to an end, people near rivers engage in the physically demanding recreation of boat racing. This ancient practice takes place during the full moon of the eleventh lunar month, in October, when the water-level is at its highest. Considered a national sport, boat racing events are arranged annually all over Thailand, from the very popular races of Pichit in the north, to those of Surat Thani in the south. An unbroken tradition of boat racing has existed for the past 200 years in remote Nan, near the Thai-Lao border. For two days in October, Nan stirs from its usual languor and comes to life with the early morning sounds of preparation for the much-anticipated festivities. Traditionally, the races were sponsored by monasteries in Nan with monks rowing the boats, giving them the much-needed physical outlet following the period of confinement during the rains. Most races are still sponsored by temples situated by the rivers, conducted in a style reminiscent of the past. Participation, however, is open to anyone who cares to join.

These traditional races, scheduled in the afternoons, last for two days as only two boats compete at a time. First is the elimination race, followed by the winners who compete against each other. As winning is so important, the rowers apply any auspicious item

which may contribute to the victory of their boat. They tie colourful gauze-like streamers to its bow to ensure success, while small Buddha images or amulets are placed at the front to encourage the rowers. In certain events, small spirit houses are erected at the starting-point of the race, with offerings of floral garlands and incense sticks placed in them. Some rowers even bless the tree-trunk from which their boat had been carved, hoping for good luck.

The racing boats are long and can seat many rowers. Fashioned mostly from hollowed-out logs, these canoe-like boats have been grouped into three categories by their size and by the number of rowers each can seat accordingly. Large boats are those that seat more than fifty-five rowers, medium-sized ones accommodate between twenty-nine and forty rowers, and small boats hold up to twenty-eight rowers. Decorative motifs include mythological beings, particularly aquatic ones like the *naga*, to enhance the boat's invincibility.

These racing boats evolved from earlier designs of naval boats of Ayutthaya. As a kingdom surrounded by rivers and canals, Ayutthaya depended greatly on its frigate of war boats to patrol and defend its waterway approaches. To keep fit during peacetime, the men practised their rowing skills by competing in boat races. This activity appealed to the local populace who crafted racing boats and enlivened the event with joyful festivities marked by singing, dancing, and religious rites. The royal chronicles of Ayutthaya mention the official boat races and the importance they had to predict the year that lay ahead. The result of this race was taken so seriously that the king and queen of Ayutthaya attended the event annually. Two traditional boats were pre-designated as auspicious and ill-fated. The victory of the auspicious boat, known as *Kraisoramook*, would ensure a peaceful and prosperous year, but a triumph of the unlucky *Samathachai* was a prediction that unrest and chaos would reign.

Present-day races do not carry the heavy burden of predicting the future. These have become fun-filled events for both rowers and spectators. The ultimate purpose is to race and win the coveted prize of Champion of the River. Well co-ordinated teams of skilful

rowers propel the boats with great speed and stamina, racing neck and neck almost to the finish line (Colour Plate 18). Not all the boats, however, finish the race successfully, as some capsize giving their crew a proper dunking, to the laughter and delight of the onlookers. At the conclusion of the races the governor of Nan presents prizes to the winners, acknowledging the fastest, prettiest, and liveliest boats. This is followed by great festivities that fill the streets with dancers, fortune tellers, boxing matches, and outdoor movies, and the ever present food and rice liquor.

Kite Flying

Kite flying is believed to have originated in Asia, earliest documented in China in the third century BC, where kites were used for warfare. Thailand's tradition of kite flying dates to the thirteenth century, to the kingdom of Sukhothai. There, and in the succeeding kingdom of Ayutthaya, kites were used for recreation, ceremonies, and warfare, a knowledge transmitted through history, legends, and temple mural paintings (Colour Plate 19). Kites used in ancient ceremonies were believed to control the winds by their fluttering sounds, chasing away the clouds before the dry season and attracting them back at its end.

Kites were forbidden to be flown over or near the royal palace, a symbolic tradition that is still followed today. Ayutthaya's historical records also tell of a rebellion in the town of Nakorn Ratchasima (Khorat) during the reign of King Phetraja, quelled by using a large kite loaded with gunpowder. It was flown over the town, setting it ablaze with this ancient method of aerial bombardment. This kite, known as *chula*, is one of the 'stars' in present-day kite fighting, used in sport rather than in warfare.

The flying of kites appealed to the kings of the present dynasty who promoted this activity. Rama II was known to fly kites at the Pramane Ground, where all major kiting events still take place, and Rama V introduced kite fighting as a team sport. The well established *chula* and *pakpao* kites were used, and kiting became an official national sport with defined rules (Plate 13). To this day, annual contests take place between February and April, the official

kite season, when strong winds blow off the Gulf of Thailand, and every open area becomes the site for flying kites.

Thai people are proficient in both making and flying kites. Traditional kites are crafted of fine bamboo frames, covered by paper made from the bark of the *sa* tree. These light and resilient materials enhance the flight of Thai kites (Plate 14). The two basic types are the flat surface kites used in sporting events, and the creative kites used for display and entertainment. A third kind, the *ngao*, a sonorous kite that produces eerie sounds, was used in the past for religious ceremonies. At present it is used mainly to frighten birds and insects from harming crops. Of the flat type, the *chula* and *pakpao* are the most popular. Designed for mobility and manipulation, they are finely crafted. The *chula*, in particular, must be

13. A man holding the *pakpao* kite used in kite fighting during the reign of Rama V. (Thai National Archives)

carefully proportioned and balanced due to its large size and unusual star-like shape. Kite flying has become a highly sophisticated sport demanding great skill and co-ordination in its teamwork. Contests are usually between a 7-foot *chula* kite, known as the 'male' kite, and several 1-foot 'female' *pakpao* kites with long tails. The object of the match is to bring the opposing kite

14. Kites on display at the Pramane Ground. (Ruth Gerson)

down into one's own area. A suspended rope marks the separate zone of each team. It is hard to get the *chula* off the ground, but once airborne, five men grab the kite manipulator around his waist, helping him control the powerful movements of the kite by holding on to a specially designed belt. The *chula* can grab the *pakpao* with one of its five prongs and bring it down. The *pakpao*, on the other hand, can team up with others to block the *chula*'s breeze, causing the kite to take a 'nosedive', or it can snag the *chula* with its double string and bring it down in the *pakpao* area. Great excitement is generated at these matches, with elated winners and disappointed losers.

The Elephant Round Up

In South-East Asia elephants are treated with high regard. For centuries, nations depended on these sturdy animals for transportation, work, and warfare, and regular hunts were held to capture them. In Thailand, most elephant round ups took place in the north-east where lush jungles once grew, with occasional excursions into Cambodia. With strict borders imposed in recent years, shrinking

jungles, and the greatly decreased number of elephants in the country, hunts no longer take place. So as not to forget the importance of elephants in Thai culture, and to generate funds for the north-eastern hunters who have lost their source of income, an elephant round up is held each year for entertainment. Revived in 1960, the town of Surin has become the centre for this exciting activity which is now a fixed event on the Thai calendar held every third weekend of November.

The Surin Elephant Round Up began as a modest event and grew into a fair with a grand show involving over 100 elephants, allowing the animals and their mahouts to display their skills and discipline. A mahout is the elephant's trainer and keeper, a term borrowed from the Hindi language but known in Thai as *kwan chang*. He looks after the animal from its capture onward. This results in a special relationship and strong bond between trainer and elephant. The mahout proudly displays his elephant, both participating wholeheartedly in the various shows and competitions.

Featured in a typical round up event in Surin is the ceremony of blessing the lasso used in elephant hunts, followed by an elephant parade, a simulated hunt, a demonstration of skill in timber work, and the re-enactment of an ancient battle when several 'warriors' charge on elephant back, handling long-handled weapons to the sound of cannons and swirling clouds of dust (Colour Plate 20). A favourite part of the programme is the elephants' display of skill and agility in sporting events. A tug of war proves to be an easy win for the animal, pitted against 200 able-bodied young men, while breath halting is the elephants' test of precision as they carefully step over recumbent men, placing their thick legs between the closely lined up bodies, without hurting them. The funniest event is a soccer match between two elephant teams. An extra large ball is kicked around and chased all over the field. The elephants, however, learn to cheat, as one picks up the ball with his trunk and carries it through the goal posts of the opposing team and scores. The Elephant Round Up ends in a grand procession, transporting royalty with great fanfare (Colour Plate 21). Both elephants and humans are bedecked in finery, a multitude of colours and glitter

fill the parade ground as they pass, creating an aura of a fairy tale come true.

People of the north-east try to keep alive the ancient tradition of trapping elephants by transmitting the hunting procedures to younger men. They recall when a mahout prepared himself spiritually for the round up, and his family, particularly his wife, had to co-operate by refraining from using oils and perfumes, cutting her hair, or having quarrels, lest the hunter may get injured or even killed by upsetting the spirits of the hunt. The spirits of the leather lasso, handed down in families for generations, are invited and blessed in a long ceremony, as is the master elephant hunter, who is given a metal hook to control the animal with. He then wraps the sacred lasso around himself and performs a dance depicting a trapped elephant.

Most elephant round ups were sponsored by the king. About 100 elephants were caught at a time, assisted by 80 tame ones. In the days of Ayutthaya numerous hunts were held. In true teamwork,

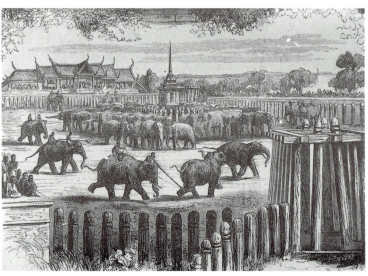

15. French engraving of elephants in the *kraal* of the king of Siam, sketched by M. Bocourt. (Thai National Archives)

an experienced elephant chose his prey, one always smaller than himself, and edged to his side to prevent escape. The frightened elephants were then chased from the jungle in great clouds of dust and herded into an enclosure known as *kraal*, a Dutch word meaning corral (Plate 15). There, in the king's presence, the capture of wild elephants took place, each tame elephant slowing down his quarry to allow the mahout to snag a leg with his lasso. The rest of the elephants were then driven into an open field to give the public a view of the round up.

The fence of the *kraal* was constructed of solid tree-trunks interwoven with sharp branches to deter the elephants from breaking out. There they were kept in uncomfortable conditions for about two weeks, often hungry and wounded by the spiked fence. Each mahout attended to his captured elephant, gaining its trust and establishing a close lifelong relationship between them. Based on their size and the ability to be tamed, the captured elephants were chosen for specific tasks, such as warfare, transportation, and general work. White elephants, rarely found, belonged (and still do) to the king as they are believed to ensure the prosperity and well-being of the kingdom.

Although no elephants are herded into a *kraal* in the Surin Elephant Round Up, one is impressed by their imposing size and strength. After the ceremony, daring spectators feed the elephants the greatly savoured sugar-cane, while others choose to ride them all the way back to town creating an unusual spectacle of elephant traffic jam. The festivities continue throughout the weekend, and the show is repeated the following day for those who missed it the first time around.

6
Royal Festivals

ROYAL anniversaries observed in Thailand as national holidays are linked to the Chakri dynasty. Founded in 1782 with the city of Bangkok as its capital, the dynasty has provided the country with remarkable kings, from Rama I, its founder, to the present Rama IX (King Bhumibol Adulyadej) each leaving a legacy of his own time. Much admired and revered by the Thais, certain events in the kings' lives have become days of observance, paying homage to the heritage of the Chakri dynasty and to the Buddha, whose teaching has guided their leaders.

Chakri Day

Chakri Day commemorates the founding of the Chakri dynasty by the general who gave it his name and established Bangkok as his capital on 6 April 1782. Born to a noble family in Ayutthaya, General Chakri, whose name was Thong Duang, held powerful positions in various parts of Siam. He was an official in Rajburi when Ayutthaya was ransacked and destroyed by the Burmese in 1767. Surviving the massacre, he, along with his younger brother, joined the forces of the famed General Taksin, and helped him repel the Burmese army. General Chakri's position as an important military commander continued throughout the following fifteen years of King Taksin's reign, in Thonburi the new capital on the west bank of the Chao Phraya River. He was on a military campaign in Cambodia when a revolt dethroned King Taksin. Upon rushing back to the capital, General Chakri was met by officers of the Siamese army and senior statesmen who offered him the throne (Colour Plate 22). After accepting, he had a brief coronation ceremony and began his reign as King Ramathibodi later taking other names. A full coronation followed later, but 6 April remains the dynastic anniversary, now observed as Chakri Day.

All the Chakri kings are known as Rama, an illustrious title given to them in the 1920s by King Vajiravudh who named himself Rama VI. The name Rama suggests virtue, righteousness as well as godliness. Hero of the *Ramayana*, the ancient Hindu epic, Rama represented the earthly incarnation of Vishnu, protector of the universe and mankind, a quality assumed by the Chakri kings. To emphasize this, the Chakri dynasty adopted the *chakra* and the trident as its emblems, the *chakra* being the disc-like weapon of Vishnu, superimposed by Siva's three-pronged weapon, a powerful combination of preservation and destruction.

Rama I had the monumental task of moving the capital across the river from Thonburi to its present location on the east bank, to distance himself from the much feared and despised Burmese. The area was known as Baan Makok, the village of olives, a name which in time evolved into Bangkok. The city's architectural style emulated that of the once glorious Ayutthaya, now in ruins, its high-spired buildings depicting the Thai concept of heaven on earth. The heart of Bangkok was marked by the City Pillar, where its guardian spirits are believed to dwell. Accordingly, the city's poetic name in Thai, the longest of any place known in the world, is 'City of Angels, great city of immortals, magnificent jewelled city of the God Indra, seat of the King of Ayutthaya, city of gleaming temples, city of [the] king's most excellent Palace and Dominions, home of Vishnu and all the gods'. It is also the city of the Emerald Buddha, Indra's jewel, and the palladium of the kingdom.

Further urgent and difficult tasks awaited the king such as establishing a government with suitable infrastructure, revising legal texts, reorganizing Buddhist institutions, and rewriting from memory literary works that perished in the fires of Ayutthaya. The succeeding Chakri kings contributed to the growth and prosperity of Siam, which became a superior power in the region. Treaties with Western and neighbouring countries were forged to secure its safety, promote trade, and develop the country by introducing such services as post and telegraph, railway systems, hospitals, and more. In that manner Siam absorbed Western ideas while maintaining its identity.

The founding day of the Chakri dynasty has continuously been

honoured by paying respects to all its kings, with special cere-
monies on the dynasty's centenary, and on the anniversaries of its
reign. In 1982, the bicentennial of the Chakri dynasty and the city
of Bangkok were celebrated with great fanfare, which included the
rarely seen Royal Barge Procession. The King, like those before
him, paid respects to the Buddha and to his ancestors.

Today, Chakri Day ceremonies are led by the King, accompanied
by the Queen, members of the royal family, palace dignitaries, and
government officials. Respects are paid to the Buddha, the Chakri
dynasty, and its founder, in that order. The King and his retinue
first visit the Emerald Buddha in the Chapel Royal, located within
the precincts of the Grand Palace. This image is considered the
palladium of the Chakri dynasty and of the city of Bangkok. The
King also pays homage to his ancestor's Buddha images and to their
ashes. The latter have been divided, like the relics of the Buddha,
and kept in several places.

Next, the King pays tribute to the former Chakri kings whose
statues are enshrined in the Ho Phra-Thebidon, the royal pan-
theon, near the Chapel Royal. This ancestral hall, designed to
resemble Mount Meru, home of the gods, is surrounded by receding
platforms and steps, and figures of mythical animals, reminiscent of
the Himaphan Forest at the foot of Mount Meru. This celestial hall
was opened in the past only on Chakri Day but is now opened on
other dynastic occasions. The ceremony in the pantheon is semi-
private. The King, accompanied by royal and official personages,
pay respects to his ancestors by lighting candles. Although ancestral
worship is an ancient custom, the ceremony performed in the
royal pantheon depicts abstract respect to the concept of kingship
and not to one particular king. It is also one of the rare times when
the public gets to see this hall.

The third ceremony of the day takes the King and his entourage
to the foot of the Memorial Bridge where a bronze statue of Rama I
sits on an elevated throne overlooking his city, Bangkok (Plate 16).
A small altar is set up for the occasion with candles and an auspi-
cious floral arrangement. The King lights the candles, paying
respects to his forebear. The public has the opportunity to share
this act of respect to the greatly admired monarch by placing floral

16. Statue of Rama I. Memorial Bridge. (Thai National Archives)

wreaths at the base of his statue. Thus end the ceremonies dedicated to the great Chakri dynasty which has kept the country at peace, cared for its people and still does, more than 200 years after its founding.

Chulalongkorn Day

King Chulalongkorn, also known as Rama V, is one of the outstanding monarchs of the Chakri dynasty (Colour Plate 23). His 42-year reign was one of the longest in Thai history, only second to that of the present monarch, King Bhumibol Adulyadej. Ascending the throne in 1868 at the young age of fifteen, following his father's death, Chulalongkorn had a grand coronation upon reaching the age of twenty. With a regent supervising the first five years of his reign, Chulalongkorn travelled to neighbouring countries observing the way these states were ruled. When crowned in 1873 he had many progressive ideas which he immediately put to work.

59

As a great reformer and modernizer of Siam, King Chulalongkorn introduced essential services to the country such as electricity, piped water, public health services, and hospitals. In the area of communications, roads and canals were built, rail links to remote regions were constructed, while the post, telephone, and telegraph came extensively into use. The King, being the first monarch to travel abroad, established government ministries and schools modelled along Western lines, with one university presently bearing his name. Additionally, he sent many of his sons and other Thai youth to be educated in prestigious institutions in Europe, particularly in England, thus planning for the continuation of the modernization that he had started.

Chulalongkorn is most noted, however, for his social reforms. He ended the feudal system in Siam, abolished slavery and forced labour, and stopped the ancient royal custom of prostration. A radical change in the traditional succession to the throne was dispensing with the position of deputy king and creating instead the new position of Crown Prince, a title the King encountered in Europe and which had appealed to him. He was also a shrewd politician who managed to keep his country free of European domination by conceding territories to both England and France, thus appeasing the two powerful nations, rendering Siam as buffer zone between them.

King Chulalongkorn reigned as a benevolent paternal monarch, becoming a father figure to the nation. To honour him, his subjects collected money to build a statue to commemorate his forty years of reign. The French artist Georges Ernest Saulo in Paris was commissioned to sculpt the magnificent bronze statue of the King riding his horse which still graces the spacious Royal Plaza in Bangkok. On 23 October 1910, the King died of kidney ailment at the age of fifty-seven. He was so greatly mourned that the date of his death has become a day of observance, paying respect to a highly honoured monarch.

Every year King Chulalongkorn, holder of the title 'The Great', bestowed on only few Thai monarchs, is remembered by the entire nation. People from all walks of life gather at the foot of his equestrian statue to give honour to this loved and respected King. On the eve of this memorial day, Buddhist services are held near

the statue followed by a Brahmin ceremony. Early on Chula-longkorn Day, groups of students, civil workers, and many others pay obeisance in front of the King's statue. They bow to him, light candles and incense, and place flowers at the foot of the statue. Organizations and prosperous citizens place elaborate floral wreaths on easels, many including Chulalongkorn's picture in the arrangement. This wonderful assemblage of colours and scents is dazzling, even giddying.

In the afternoon the King and Queen pay respects to their great ancestor at the Royal Plaza. They too light candles and lay wreaths at his statue, then proceed to the Amarintra Hall in the Grand Palace to pay homage to his ashes and to the Buddha image casted during his reign. (Every Chakri king casts a Buddha image for each year of his rule, but only one image symbolizes his reign.) Memorial rites are held accompanied by Buddhist chants, remembering once more King Chulalongkorn the Great, a brilliant man whose reign was a brilliant era.

Coronation Day

On 5 May each year, the Thai nation celebrates Coronation Day, the anniversary of King Bhumibol Adulyadej's ascent to the throne as Rama IX. Following the death of his brother Rama VIII (King Ananda Mahidol) in 1946, he became king. Wanting to complete his studies in science and law at Lausanne University in Switzerland, he delayed formal coronation until 1950.

Coronation ceremonies were already known to have taken place in the Sukhothai period, but commemorating their anniversaries was an innovation of the Chakri dynasty trying to keep in step with other countries. Hindu in origin, the ceremony invites the god Vishnu to enter the king's body as the earthly Rama, giving the king a divine name and presenting eight godly weapons as part of the royal regalia. Like most royal and state ceremonies in Thailand, the coronation includes both Hindu and Buddhist rites. The day, known as Wan Chatra Monggol, means 'The Day of Blessing the Royal Umbrella', referring to the nine-tiered white umbrella, its lower tiers representing the eight directions of the

wind, topped by the ninth, denoting the king's rule over the entire domain. At this ceremony the umbrella and the royal regalia are sprinkled with lustral water and religious rites take place. Unlike the grand coronations in the West, Thai coronation ceremonies are small, attended only by the royal family and the officiating persons.

Although the word coronation implies placing a crown on the head, the main ritual is the *a-pisek*, wherein the new king receives lustral water from his subjects who invite him to rule over them, giving their oath of fidelity, while the king accepts (Plate 17). This water is collected from eighteen wells located in temples throughout the country whose *chedi* enshrined relics of the Buddha. The collected water is then taken to the Octagonal Throne in the Baisal Hall of the Grand Palace where it is presented by Brahmin priests and court officials in attendance representing the people from the eight cardinal points of the kingdom. Starting from the eastern point, the king moves clockwise around the eight-sided throne, sipping and touching the water given to him by each representative until he completes the circle. This lustral water is also used for royal ablution rites.

The number of tiers on a royal umbrella indicates a person's rank, from three tiers for low-ranking royalty to the nine-tiered umbrella for the king. The seven-tiered umbrella over the Octagonal Throne in the Baisal Hall indicates that the monarch has not fully assumed his kingship yet. Next, the king is presented with the royal regalia which he dons. He then moves to the Noble Throne, also in the Baisal Hall. This throne, covered by a nine-tiered umbrella, marks his full kingship. There he crowns himself and pledges to uphold the tenfold principles of a king, and receives the blessings of the royal household. He also bestows upon his wife the title of queen, and declares himself a Buddhist and defender of the faith. Lastly, the king goes to the Amarintra Hall and occupies the royal throne in full regalia. It is from this throne that the king grants formal audiences to distinguished personages and presides over royal ceremonies.

The following day their majesties proceed to the royal bed-chamber in the palace for the Assumption of Residence Ceremony. The king is presented the key to the treasury, indicating his new

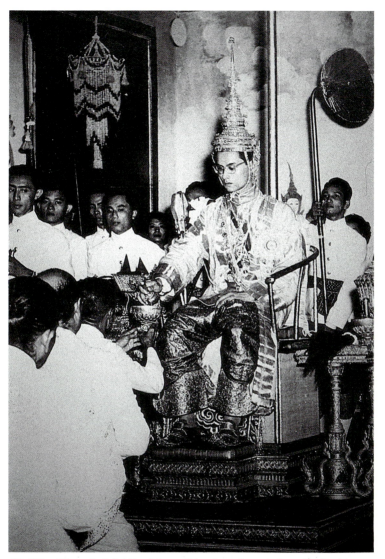

17. King Bhumibol Adulyadej receiving lustral water from Brahmin priests during coronation ceremonies at the Grand Palace, 5 May 1950. (Thai National Archives)

position, then he lays on the couch formally completing the ceremonies.

Today, the observance of Coronation Day starts on the preceding day when the King and Queen pay their respects to the ashes of their ancestors at the Amarintra Hall in the Grand Palace. Buddhist prayers follow, and honours are conferred on high-ranking monks. On the morning of Coronation Day, Their Majesties proceed to the Dusit Maha Prasat Throne Hall, offer food to the monks, light candles of worship, and sprinkle lustral water on the royal regalia. A sort of *wien tien* or circumambulation is performed by passing lit candles from hand to hand three times around the royal regalia. In the afternoon, the King bestows the royal order of Chulachomklao on members of his family and officials (Plate 18). The ceremonies conclude with auspicious prayers and blessings.

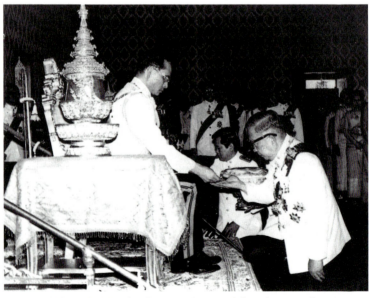

18. King Bhumibol Adulyadej presenting medals to honoured persons on the occasion of Coronation Day. Dusit Maha Prasat Throne Hall, Grand Palace. (Thai National Archives)

The Birthday of King Bhumibol Adulyadej

King Bhumibol Adulyadej, the ninth king in the Chakri dynasty, is the longest reigning monarch in Thai history (Plate 19). On 2 July 1988 he surpassed the 42-year reign of his grandfather, King Chulalongkorn. An event named the Rachamangkhalapisek, or the Longest Reign Celebration, honoured this achievement. Like his grandfather, he received the title 'The Great', an honour shared by few other Thai sovereigns. During his long reign King Bhumibol has striven to fulfil the functions of a caring and benevolent ruler, to ensure the welfare of the people, and to uphold the vows he had taken upon ascending the throne. Due to his paternal attitude towards his subjects, the King's birthday has been adopted as the official Father's Day in Thailand. A hard-working monarch possessing a natural quality of leadership, he has dedicated his life to the well-being of the nation, which in return has elicited devotion and loyalty from the people. Thus every year his birthday anniversary is celebrated by all.

The King was born on 5 December 1927 in Cambridge, Massachusetts, to Prince Mahidol of Songkla, son of King Chulalongkorn, and Mom Sangwal. The youngest of three children, he was given the auspicious name Bhumibol Adulyadej meaning, 'Strength of the Land Incomparable Power', as if foretelling his future. Orphaned of his father before the age of two, the King, after a short stay in Thailand, moved with his mother and family to Switzerland where he grew up and attended university. It was there that he met his future wife, Mom Rajawong Sirikit Kitiyakara. Following his brother's death in 1946 he succeeded to the throne. He married MR Sirikit in April 1950 and was formally crowned as King of Thailand a few days later.

After fifty years of reign, the King can look back on a fruitful life, filled with excitement as well as difficult times, all of which he has handled in a truly noble way. A man of many talents and varied interests, he places the country's welfare ahead of himself, initiating sorely needed projects whose progress he follows, often visiting their sites.

Celebrating a birthday was not originally a Thai custom. It was

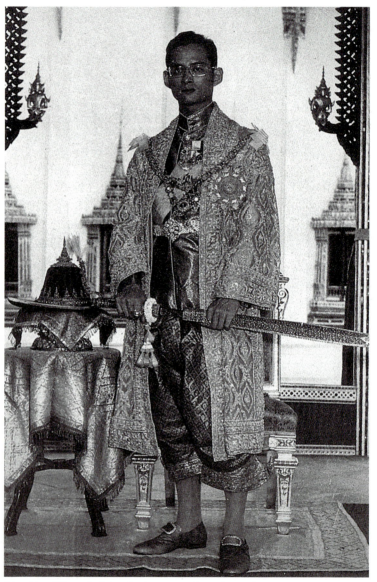

19. King Bhumibol Adulyadej in royal regalia. (Thai National Archives)

introduced through Chinese tradition by Rama IV as were a few other customs and ceremonies. For a Thai it is more important to know the hour, day, and month of his birth, and which animal in the Buddhist twelve-year cycle was presiding that year. This information is used in plotting a person's horoscope, a chart considered essential in life. But reaching sixty years of age is regarded as very important among the Thais as it is considered the attainment of the grand cycle, the most significant in a series of cycles in a person's life, each cycle lasting twelve years. The King's sixtieth birthday celebration in 1987 included year-long festivities, affording the public the best of Thai and Western cultures.

The King's birthday is celebrated for three days, from 3 to 5 December, with rituals that include Buddhist prayers, merit-accumulating ceremonies, and a visit to the Chakri ancestral hall. On the first day of celebrations, a military parade, known as the Trooping of the Colours, is held at the Royal Plaza. It is a time when all soldiers reaffirm their allegiance to the King, the formal ceremony reminiscent of Siam's ancient glory. The King reviews representatives of all branches of the armed forces, each unit attired in distinctly colourful uniforms, transforming the usually drab-looking plaza into a brilliant kaleidoscope of colours. On the second day, the King and Queen preside over the consecration rites of the new Buddha image cast to mark the King's birthday and his year of reign. The image is added to those marking the annual reign of each Chakri monarch. A garden party is customarily given where the King meets dignitaries and diplomats, but this has been discontinued of late. On the King's birthday, Their Majesties perform religious rites at the Temple of the Emerald Buddha, and offer food to the monks. They later go to the Amarintra Hall where the King confers prestigious royal decorations to those who merit the honour. It is also an occasion for official promotions, and a time when prisoners may be granted pardon.

The entire nation celebrates the King's birthday, flying high the Thai flag and decorating their homes with colourful lights. In Bangkok, people converge at the main avenue leading to the Grand Palace and the surrounding area which is set ablaze with bright lights and signs conveying the affection the Thais have for

their King. At a pre-arranged time each person lights a candle and joins in singing 'Long Live the King'.

The Birthday of Queen Sirikit

Queen Sirikit, a descendant of the Chakri dynasty, possesses qualities that make her truly regal. With her widely acclaimed beauty, Queen Sirikit's name has been synonymous for years with Thailand. Her deep concern for the people and her unfailing dedication in initiating and carrying out a multitude of programmes, has been recognized and praised in Thailand and abroad.

Born in Thailand on 12 August 1932 to Prince Nakkhatmongkol Kittiyakara and ML Bua Kittiyakara, the Queen gained much knowledge and experience in her youth, having been educated in Thailand and in Europe. She joined her family in England where her father served as ambassador to the court of St James's, and later as ambassador to Denmark and France. This gave the young Sirikit an opportunity to develop her linguistic skills, mastering several languages, while her musical talent for playing the piano grew. It was in Europe that she met her future husband, an event that changed her entire life. A 1949 engagement was celebrated in Thailand followed by a 1950 wedding. The King's coronation a few days later elevated Sirikit to the full rank of Queen.

Queen Sirikit took on her new position with confidence, displaying skills of a caring mother, while instilling a sense of duty for the country in her four children. In recognition of these attributes, 12 August, the day of her birthday, has been observed since 1976 as National Mother's Day in Thailand. Serving as president of the Thai Red Cross Society for many years, the Queen has demonstrated compassion and responsibility, initiating programmes for rural medical care, such as the Village Doctor Programme and training volunteers to administer basic health care. This and other achievements brought the Queen universal recognition, receiving awards from the Philippines and the United States, and being conferred honorary doctoral degrees by American universities.

The Queen's concern for the social conditions of the people, particularly the plight of farmers and low-income labourers in rural

areas, continues unwavering. Her efforts in seeking ways to supplement their income led to the setting up of a new organization. Established in 1976, the Foundation for the Promotion of Supplementary Occupations and Related Techniques (SUPPORT) became a major source of income for many villagers. In her travels, the Queen observed which crafts were predominant in what regions of the country, and planned her workshops accordingly. *Mudmee (ikat)* silks from the north-east which the Queen wore to promote, and *Yan-lipao* handbags made of rare vine found almost exclusively in the south, became symbolic of the revival of ancient Thai crafts. Training centres were built and equipped by the Queen's foundation. The best known is located at the Chitralada Palace, the royal place of residence, where apprentices learn every Thai craft from wood and silver work, to embroidery and pottery.

20. Queen Sirikit lighting candles on her birthday in a religious ceremony in the Baisal Taksin Throne Hall in the Grand Palace. (Office of His Majesty's Principal Private Secretary)

Select pieces are displayed in the SUPPORT Museum in the Abhisek Dusit Hall.

Queen Sirikit's support of women's issues was acknowledged in 1979 with the UN Ceres Gold Award for helping women in agriculture, followed by the prominent recognition given during the 1992 UN Year of the Woman. These are but two of the many awards conferred on her. The number of awards that abound are indicative of the Queen as a multifaceted person, one who cares and gives a helping hand.

In the past only a monarch's birthday was designated as a national holiday. This changed when Queen Sirikit became regent during the King's period of monkhood, an act required of all Buddhist men. Upon his return, the King conferred on her the honoured title of Somdej Phra Borom Rajini Nath which translates as 'Full Reigning Queen'. In 1992 she completed the auspicious fifth cycle, celebrating her sixtieth birthday. Being a significant event, a year of celebration was observed, and outstanding performances were presented to the public.

On her birthdays, she attends a prayer service and blessing ceremony in the morning at the Chitralada Palace where she lives (Plate 20). Later, she offers food and gifts to the monks. In the afternoon the Queen receives birthday wishes from friends, officials, and dignitaries. For several days the city is festively decorated and lit brightly while the people wish the Queen a long and happy life.

7
Conclusion

THIS century has seen more changes in the world than any other time in history. The advent of electronic communications has made all geographic and cultural borders permeable, with nations eager to adopt the traits of others. In such an atmosphere Thailand's cultural past is endangered, and with it the many traditions that make the country and its people so unique. Traditional life-styles give way to newly introduced comforts, while Western music, food, and dress mesmerize and overwhelm the Thai people, particularly the young.

The Thais, however, have always been aware of their heritage with great pride. They were brought up practising traditional customs in many facets of their daily lives: at home, at school, at the temple, and everywhere else. Although many of these customs are still evident, they appear somewhat diluted. This is understandably so, as people have become more sophisticated over the years, shedding those ancient beliefs which no longer have place in their lives. Occasionally, when an ancient custom is remembered, it is treated as a superstition or it becomes part of an accepted ritual.

Fortunately, the Thais are alert to the perils that may endanger their heritage. To ensure the continuity of their culture, they take great care in teaching the young their religion, history, traditional customs, and the arts. To make sure that adults too remember their culture, programmes are held to propagate, and in some cases to revive the old traditions and festivals. This awareness is on all levels, from the rural classrooms up to the highest government offices and members of the royal family. Recently, public funds have been allocated for preserving the Thai heritage. Although this is admirable, the danger of 'overdoing' the cultural revival is always present, as a very fine line exists between the old elegant practices and the new gaudy ones. In general, the Thais manage to escape this trap; none the less, it is still there, and one must be cognizant of it.

71

One of the threats of obliterating Thai culture is tourism. In efforts to provide visitors to the country with colourful events the year round, the Tourist Authority of Thailand has attempted to celebrate the many festivals with great fanfare as these visitors provide Thailand with a good revenue. The villagers and townspeople involved in the festivals are also eager to have this once-a-year special income, and occasionally tailor the events to suit tourism. Residents of the north-east, however, are more resistant than most to change, as the majority of them are farmers and the rituals they perform during the annual festivals are for placating the forces of nature so as to receive plentiful rain and an abundant harvest in the coming year.

Besides the main festivals mentioned in this book there are regional festivals also marked by parades and public celebrations. Many new festivals have appeared since the early 1980s, such as the Flower Festival in Chiang Mai up in the north, the Silk Festival in Khon Kaen in the heart of the north-east, the Dragon Festival in Nakorn Sawan and the Straw Birds near Uthai Thani, both in the central plains. Numerous temple festivals are also held yearly with the purpose of raising funds for the temple. Such festivals can be seen in the Nakorn Pathom Chedi Festival south-west of Bangkok, and the Golden Mount Festival in the centre of the city. Not included are Chinese New Year and similar festive holidays which are celebrated world-wide too.

Traditional festivals in Thailand, whether old or somewhat new, are part of the lives of the Thais. They symbolize important events in their heritage and are therefore observed and perpetuated annually. Due to the people's deep religious beliefs and pride in their rich heritage, the colourful festivals will still be celebrated in years to come.

Appendix

Calendar of Traditional Festivals in Thailand

Date	Festival	Location	Type
January	Swing Ceremony	Bangkok	Lunar
February	Maka Bucha	Nation-wide	Lunar
March–April	Kite Flying	Nation-wide	Seasonal
6 April	Chakri Day	Bangkok	Fixed on calendar
13–15 April	Songkran	Nation-wide	Fixed on calendar
5 May	Coronation Day	Bangkok	Fixed on calendar
Mid-May	Ploughing Ceremony	Bangkok	Decided by court astrologers
May–June	Rocket Festival	North-east region especially Yasothorn	Seasonal
May–June	Visaka Bucha	Nation-wide	Lunar
June	Ghost Festival	Dan Sai, Loei province	Decided by village medium
July	Candle Procession	Ubon Ratchathani, Ubon province	Lunar
July	Asalaha Bucha	Nation-wide	Lunar
July	Khao Pansa	Nation-wide	Lunar
12 August	Queen's Birthday	Bangkok	Fixed on calendar
September–October	Boat Races	Nan, northern region	Seasonal
October	Ohk Pansa	Nation-wide	Lunar
October	Royal Barge Procession	Bangkok	Decided by royal court
October	Devo Ceremony	Northern region	Seasonal

(continued)

Appendix (*continued*)

Date	Festival	Location	Type
October	Chak Phra	Surat Thani, southern Thailand	Seasonal
October–November	Thot Kathin	Nation-wide	Seasonal
23 October	Chulalongkorn Day	Bangkok	Fixed on calendar
November	Loy Krathong	Nation-wide	Lunar
November third weekend	Elephant Round Up	Surin, north-east region	Fixed on calendar
5 December	King's Birthday	Bangkok	Fixed on calendar

Select Bibliography

Arya, M. K., *The Coronation of His Majesty Prajadhipok King of Siam, B.E. 2468*, Bangkok, 1925.

Buahapakdee, Apinan, 'Festival of Mischief, Ghosts, and Phallic Symbols', *Saen Sanuk*, June 1988, pp. 53–6.

Buddhism in Thai Life, Bangkok, Public Relations Department, Office of the Prime Minister, 1981.

Chakrabongse, Prince Chula, *Lords of Life, a History of the Kings of Thailand*, 2nd edn., London, Alvin Redman, 1967.

Davis, Bonnie, *His Majesty King Bhumibol Adulyadej, the Longest-Reigning Monarch of the Kingdom of Thailand*, Special Publication, Bangkok, Bangkok Post, 1988.

Davis, Bonnie and Thongtham, Normita, *A Fifth Cycle Tribute to Her Majesty the Queen*, Special Publication, Bangkok, Bangkok Post, 1992.

Davis, Reginald, *The Royal Family of Thailand*, London, Nicholas Publications, 1981.

Gray, Denis (ed.), *The King of Thailand in World Focus*, Bangkok, Foreign Correspondents Club of Thailand, 1988.

Intravutr, Tira (ed.), *Royal Barges, Poetry in Motion*, Bangkok, Public Relations Department, Office of the Prime Minister, 1982.

Kamchanachari, Nongyao (ed.), *The Chakri Monarchs and the Thai People, a Special Relationship*, Bangkok, Publication Committee for the Rattanakosin Bicentennial Celebration to Commemorate the Rattanakosin Bicentennial, 1982.

Klausner, William J., *Reflections on Thai Culture*, 4th edn., Bangkok, Siam Society, 1993.

Manilerd, Chaleo (ed.), *Thai Customs and Beliefs*, Bangkok, Office of the National Culture Commission, Ministry of Education, 1988.

A Memoir of His Majesty King Bhumibol Adulyadej of Thailand, Bangkok, Office of His Majesty's Principal Private Secretary, 1987.

Mulder, Niels, *Inside Thai Society*, 3rd edn., Bangkok, Duang Kamol, 1992.

Narula, Asha (ed.), 'Pichit Boatrace, a Show of Speed and Musclepower', *Lookeast*, September 1992, pp. 38–9.

Niwat, Prince Dhani, *Coronation at the Bang Pa'ing Palace*, Printed in honour of a Thai Prince on the occasion of his cremation (BE 2509), Bangkok, 1966. Text in Thai.

Plion-Bernier, Raymond, *Festivals and Ceremonies of Thailand*, translated from the French by Joann Elizabeth Soulier, Bangkok, Sangwan Surasarang Publisher, 1973.

Rajadhon, Phya Anuman, *Popular Buddhism in Siam, and Other Essays on Thai Studies*, Bangkok, Thai Inter-Religious Commission for Development and the Sathirakoses Nagapradipa Foundation, 1986.

————, *Essays on Cultural Thailand*, Bangkok, Office of the National Culture Commission, Ministry of Education, 1990.

————, *Essays on Thai Folklore*, Bangkok, Duang Kamol, 1968.

Rajavaramuni, Phra (Prayudh Payutto), *Thai Buddhism in a Buddhist World*, 3rd edn., Bangkok, Mahachulalongkorn Buddhist University, 1985.

Rapiphadana, Akin, *Tourism and Culture: Bang-Fai Festival in Esarn*, Background report [on] the 1992 Year-End Conference in Chon Buri, Bangkok, Chai Pattana Foundation and the Thailand Development Research Institute Foundation, 1992.

Rogers, Peter, *A Window on ISAN, Thailand's Northeast*, Bangkok, Duang Kamol, 1989.

Rosenthal, Laurie (ed.), *Great Celebrations for a Great King*, Bangkok, Nation Publishing Group, 1988.

Royal Barges, Bangkok, Fine Arts Department, 1982.

The Royal Household, *Detailed Program of the Coronation of King Rama VII*, Bangkok, Fine Arts Department, (BE 2468) 1925. Text in Thai.

Schappli, Werner, *Feste in Thailand*, Bonn, Deutch-Thailandische Gesellschaft, 1985.

Segaller, Denis, *More Thai Ways*, Bangkok, Allied Newspapers Limited, 1982.

————, *Thai Ways*, Bangkok, Allied Newspapers Limited, 1979.

————, *Traditional Thailand, Glimpses of a Nation's Culture*, Hong Kong, Hong Kong Publishing Company, Ltd., 1982.

Sukhsvasti, MC Prasobsukh, 'Bun Bong Fai', *Holiday Time in Thailand*, April 1980, pp. 57–62.

Tachard, Guy, *Voyage de Siam des Peres Jesuites, Envoyez par le Roy aux Indes & à la Chine*, A Paris, Seneuze et Horthemels, 1686.

Terwiel, B. J., *A Window on Thai History*, 2nd edn., Bangkok, Duang Kamol, 1991.

Thailand Celebrates, Bangkok, Nation Publishing Group, 1986.

Thailand in Brief, 3rd edn., Bangkok, Foreign News Division, Public Relations Department, Office of the Prime Minister, 1979.

Traikasem, Saengchan, *Thai Kites*, translated from the Thai by MR Chakrarot Chitrabongse, Bangkok, Fine Arts Department, 1986.

Wales, Quaritch, *Siamese State Ceremonies*, Surrey, Curzon Press, 1931; reprinted 1992.

Walton, Geoffrey (ed.), *A Northern Miscellany, Essays from Thailand*, 2nd edn., Chiang Mai, Silkworm Books, 1992.

Wells, Kenneth E., *Thai Buddhism, Its Rites and Activities*, 3rd edn., Bangkok, Suriyabun Publishers, 1975.

Wilson Ross, Nancy, *Buddhism, a Way of Life and Thought*, New York, Vintage Books, 1981.

Wyatt, David, *Thailand: A Short History*, New Haven, Yale University Press, 1984.

Index